THE ART OF THE
GOLDEN WEST

WILLIAM C. KETCHUM, JR.

SMITHMARK

This edition published in 1996 by
SMITHMARK Publishers,
a division of U.S. Media Holdings, Inc.,
16 East 32nd Street, New York, NY 10016.

SMITHMARK books are available for bulk purchase
for sales promotion and premium use.
For details write or call the manager of special sales,
SMITHMARK Publishers,
16 East 32nd Street, New York, NY 10016;
(212) 532-6600.

This book was designed and produced by
Todtri Productions Limited
P.O. Box 572, New York, NY 10116-0572
FAX: (212) 279-1241

Printed and bound in Singapore

Library of Congress Catalog Card Number 96-67875

ISBN 0-7651-9972-6

Author: William C. Ketchum, Jr.

Publisher: Robert M. Tod
Book Designer: Mark Weinberg
Production Coordinator: Heather Weigel
Senior Editor: Edward Douglas
Project Editor: Cynthia Sternau
Assistant Editor: Don Kennison
Picture Researcher: Laura Wyss
Desktop Associate: Paul Kachur
Typesetting: Command-O, NYC

PICTURE CREDITS

American Museum of Natural History, New York 15, 16, 17

Autry Museum of Western Heritage, Los Angeles, California 54-55, 59 (top)

The Berkshire Museum, Pittsfield, Massachusetts 71

The Brooklyn Museum of Art, Brooklyn, New York 48, 102

Buffalo Bill Historical Center, Cody, Wyoming 34, 37

California Historical Society, San Francisco 75, 84-85

Amon Carter Museum, Fort Worth, Texas 7, 11, 36, 38, 49, 53, 64, 90, 92, 93, 94, 95, 96, 99, 100, 103, 104-105, 106, 108, 109, 110-111, 112, 113, 114, 115, 116-117, 118, 119, 120-121

Columbus Museum of Art, Columbus, Ohio 70

Cooper-Hewitt, National Design Museum, New York 78, 79

The Corcoran Gallery of Art, Washington, D.C. 39, 42

Crocker Art Museum, Sacramento, California 87

Denver Art Museum, Denver, Colorado 58

Esto Photographics 122, 123, 124, 125

The Fine Arts Museums of San Francisco, California 88-89

Archer M. Huntington Art Gallery, University of Texas at Austin 56-57

Joslyn Art Museum, Omaha, Nebraska 4, 22, 26 (top & bottom), 27 (top & bottom), 29, 32, 40-41

Milwaukee Art Museum, Milwaukee, Wisconsin 59 (bottom)

Mount Holyoke College Art Museum, South Hadley, Massachusetts 68, 74

Museum of Fine Arts, Boston, Massachusetts 66-67, 72-73

The National Gallery of Art, Washington, D.C. 63

National Museum of American Art, Washington D.C./Art Resource 5, 12, 14, 18 (bottom), 76, 83

Nawrocki Stock Photo 18 (top), 20, 21

The Nelson-Atkins Museum of Art, Kansas City, Missouri 80-81

The Oakland Museum, Oakland, California 86

Peabody Museum, Harvard University, Cambridge, Massachusetts 52, 126-127

Philbrook Art Center, Tulsa, Oklahoma 77, 82

Frederic Remington Art Museum, Ogdensburg, New York 10

The Rokeby Collection, Barrytown, New York 51

Sid Richardson Collection of Western Art, Fort Worth, Texas 8-9, 97, 101

The Saint Louis Museum of Art, St. Louis, Missouri 45, 46-47, 60, 61, 65 (top)

The Shelburne Museum, Shelburne, Vermont 50

Stark Museum of Art, Galveston, Texas 43, 62

The State Historical Society of Missouri, Columbia, Missouri 65 (bottom)

University of Michigan Museum of Art, Ann Arbor, Michigan 44

Walters Art Gallery, Baltimore, Maryland 6, 24-25, 28, 30, 31, 33

CONTENTS

INTRODUCTION

The lure of the American West began in earnest in 1803 with the Louisiana Purchase, which effectively doubled the size of the United States, adding to it some 825,000 acres (334,125 hectares) stretching from the Mississippi River to the Rocky Mountains. Bought from France for a mere fifteen million dollars, this vast domain was then largely unknown. Though the Spanish explorer Francisco Vásquez de Coronado had discovered the Colorado River and Rio Grande in 1640 and pushed as far north as what is now eastern Kansas; and French trappers (*coureurs de bois,* or "woods runners") had within a few decades penetrated as far west as the Rocky Mountains and as far south as present day Santa Fe, information about what lay beyond the Mississippi had not been adequately provided.

Left to the imagination, writers described vast savannas of head-high grass; soil so rich that planting might be—as one described it—"dangerous"; empty deserts; and, towering over all, the great Stony or Shining Mountains crowned by a ridge of salt 180 miles long (290 kilometers). In fact, though, no one rightly knew where or if any of this was, and the few maps that existed were notoriously inaccurate.

English-speaking explorers had been slow to go west. Alexander MacKenzie, a Scottish fur trader, reached the Pacific through Canada in 1793; but it was the purchase of 1803 that spurred the first organized scientific expedition. In 1804, President Jefferson sent Meriwether Lewis and William Clark with a party of thirty to explore the headwaters of the Missouri. Starting in May of that year they moved northwest up the river, eventually crossing the Rockies, journeyed down the Columbia River, and saw the ocean for the first time in November of 1805.

Bison-Dance of the Mandan Indians

FROM A PAINTING BY KARL BODMER *c. 1833–1834, colored engraving. Joslyn Art Museum, Omaha, Nebraska.* Bodmer spent the winter of 1833 among the Mandan, and his paintings remain the most powerful rendition of these remarkable but doomed people.

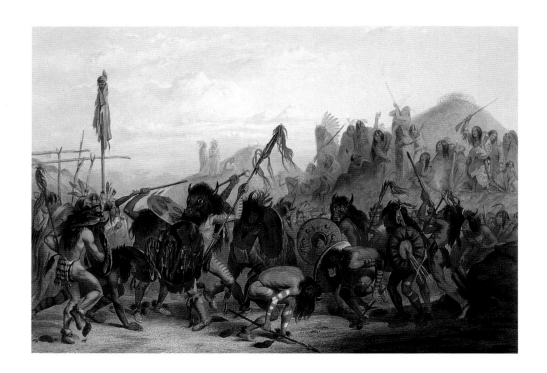

Returning to St. Louis in September of 1806, the expedition arrived with a vast array of scientific and ethnographic material, reasonably accurate maps, and news of generally friendly contacts with the numerous Indian tribes encountered along the way. Yet, oddly enough, they brought back no images. They had neglected to include an artist in the group, and the first published accounts of the expedition were illustrated with distinctly Iroquoian (the Six Nations people of northern New York) woodcuts.

Following on the heels of Lewis and Clark, explorers, hunters, and trappers began to visit the new territory. They soon proved to be among the most reliable sources of information on the great West. Company trappers and, after 1822, independent or "free trappers" scoured every plain and mountain valley for beaver and other skins; then, as tastes changed and their source of supply dried up after 1840, they became reliable guides for government expeditions and even tourists.

Still there were no paintings to satisfy the curiosity of a public excited by the travels of Lewis and Clark, as well as by Zebulon Pike's *Account of the Expeditions to the Sources of the Mississippi*, and similar works. Only three artists are known to have penetrated the remote fastnesses prior to 1830: Samuel Seymour, who traveled to the foot of the Front Range in 1820 with Stephen H. Long's expedition up the South Platte River; Joshua Shaw, said to have cruised the Missouri in the same year; and Peter Rindisbacher, who lived with settlers on the Red River from 1821 through 1826. Of these three, only Seymour's work, and precious little of that, has survived. A half dozen crude sketches served to illustrate a rare book on the Long expedition.

All this changed in 1830 when George Catlin arrived in St. Louis determined to devote himself to painting the West and particularly its Native

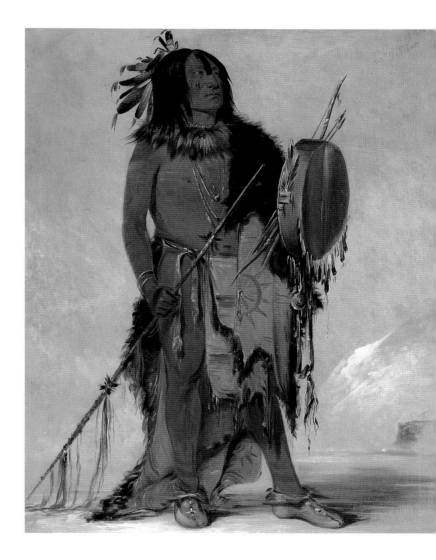

White Buffalo:
An Aged Medicine Man

GEORGE A. CATLIN

1832, oil on canvas. National Museum
of American Art/Art Resource.
Though he initially had difficulty
inducing them to pose for him,
chiefs and medicine men became
Catlin's most eager subjects.

Rendezvous

ALFRED JACOB MILLER

c. 1837–1840.

oil on canvas.

Walters Art Gallery,

Baltimore, Maryland.

Among Miller's most
important works
are those capturing
the great annual
gatherings of Indians,
fur traders, and
mountain men which
took place in the
Rocky Mountains.

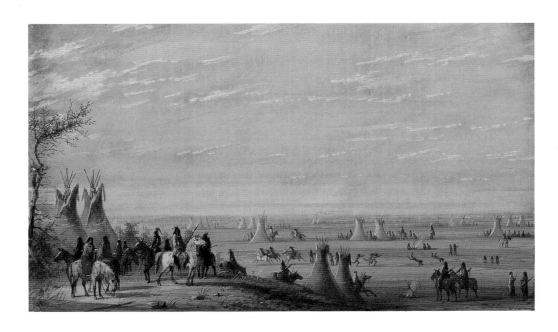

American inhabitants. Already a well-known portrait artist, Catlin was determined to picture what he saw as accurately as possible. This was significant, for American and European artists had a long history of painting Indians in the most fanciful manner, imbuing them with African, Asian, or Near Eastern characteristics without a true sense of what they looked like, how they dressed (there was great variety from tribe to tribe), or how they lived.

Catlin and another painter, Karl Bodmer, who arrived in the West in 1832, were more than artists. They were ethnographers concerned with the study of the Native Americans' way of life. They were also illustrators whose audience was initially concerned with seeing what people and things looked like "out West." They were not romantics who applied artistic license to their subject matter. They painted what they themselves observed.

Both produced large numbers of portraits of Indian notables—chiefs, famous warriors, medicine men, and the like. Such work was very much within the contemporary European tradition which valued portraits more highly than any other form of painting; for some years previously Catlin and other artists had been painting Native American dignitaries who visited Washington and other eastern cities.

Though less in favor with art critics and wealthy collectors, other forms such as genre and history paintings and landscapes soon made their appearance on the western Great Plains and proved exceedingly popular with a mass audience, especially when translated into inexpensive prints. The tradition of the genre or "real life" painting was well known in Europe (one need only think of the work of Flemish painter Pieter Brueghel). In the United States its great champion was William Sidney Mount, whose paintings of life among the farmers and artisans of New York's Long Island set the standard for western genre painters like Catlin, Alfred Jacob Miller, and George Caleb Bingham. There was a difference, though: Mount and Bingham, like Brueghel, painted a life of which they were a part. Catlin, Bodmer, and many who came after them, painted what was actually a foreign land; hence the term "exotic genre" was sometimes applied to their work.

The great popularity of these dramatic compositions reflected more than the usual voyeur's interest in violence. They also mirrored a popular prejudice against Native Americans, who were seen to be standing in the way of America's manifest destiny to control the entire continent. Catlin and Bodmer genuinely liked and respected Native Americans, though many of the later artists were indifferent or hostile to them.

Indeed, even those who sympathized with their plight urged artists to capture pictures of the

Indian way of life before it entirely faded away. This "fading away" is exemplified by the paintings of the Rocky Mountain School of landscape artists, whose adherents often managed to produce gigantic canvases featuring Western scenes utterly devoid of human, particularly Indian, life.

By the 1860s the voyagers, mountain men, flatboatmen, and many of the Native Americans who had served as subjects for the early artists of the West were vanishing. The landscape artists came into their own, with painters like Albert Bierstadt and Thomas Moran testing their skills against the vastness of the Rockies and the Yellowstone valley, and genre artists such as William T. Ranney focusing their efforts on the immigrants crossing and settling the Plains and the "buffalo runners,"

who, supplanting the Indian hunting parties, hounded the vast herds nearly to extinction for their hides and tongues.

Then, in a rush, came the cowboys, defining the last great chapter of the Western drama. In 1865 the Kansas Pacific Railroad reached Abilene, providing a depot from which steers could be shipped to Chicago and the eastern markets. For the next thirty years herds, often numbering in the many thousands, were driven up the Chisholm, Western, or Goodnight-Loving trails to the booming "cow towns." The men who drove them—cowboys, wranglers, cowhands, or cowpunchers, as they were variously known—appeared to eastern writers and artists as a romantic lot; and though their lives were hard and

Cowboy Camp during the Roundup

CHARLES M. RUSSELL

c. 1885–1887, oil on canvas. Amon Carter Museum, Fort Worth, Texas.
One of Russell's earliest works, this painting was commissioned by a saloon owner and hung for years in "The Mint," a well known Great Falls, Montana watering place.

FOLLOWING PAGE:
The Sentinel
FREDERIC S. REMINGTON
1889, oil on canvas. Sid Richardson
Collection of Western Art, Fort Worth, Texas.
Though less interested in the Mexican vaquero than in American cowboys, Remington's renderings of this hardy breed capture the flavor of life in old Mexico.

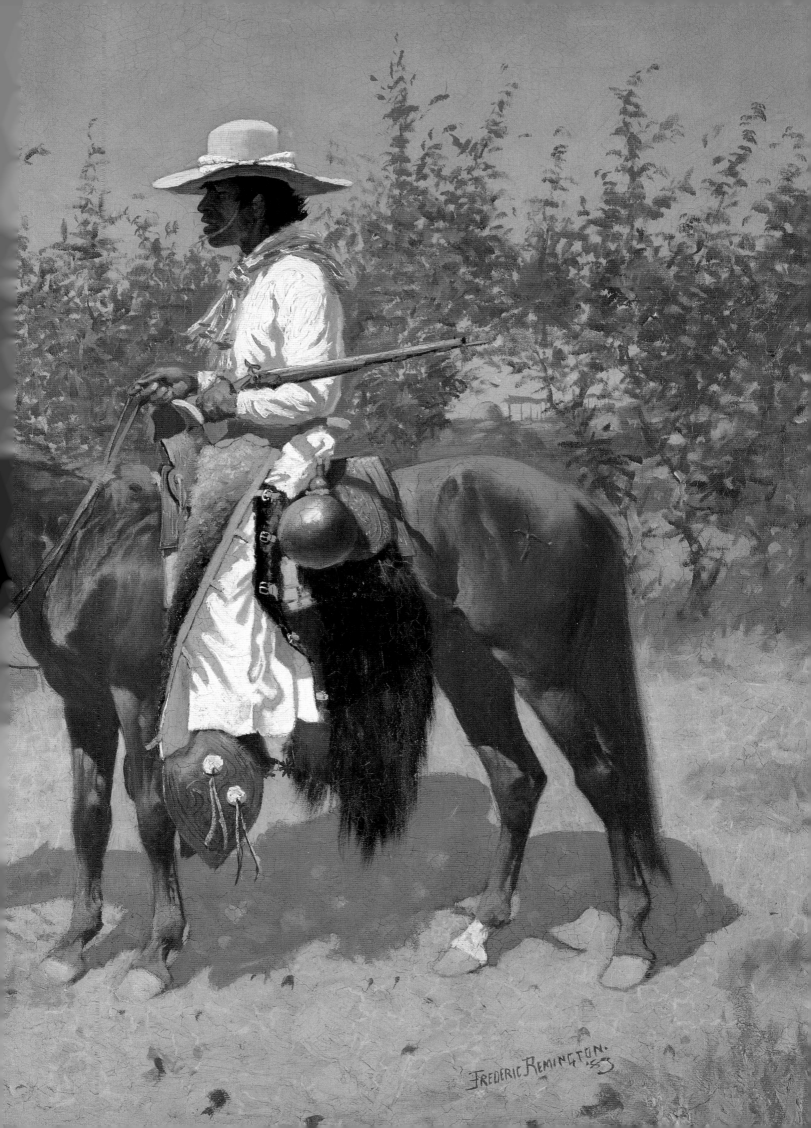

often short, they left a legacy that still resonates in American art, literature, and cinema.

The greatest chroniclers of the saddle life were Frederic Remington and Charles M. Russell. Both were easterners who came from well-to-do families; they came late to the Western scene, working during the 1880s and 1890s when the cattle drives were ending and the great prairies were being fenced and sold to farmers—the "sod busters," so despised by cattlemen.

Though alike in their fondness for the West and, to some extent, in their work (both painted and sculpted, a rare combination in Western artists), Remington and Russell held very different views of life on the Great Plains. An obvious distinction between the two artists was in their attitude toward Native Americans. Remington had ridden with the United States Cavalry on punitive expeditions against recalcitrant bands, and showed little sympathy for the desperate remnants of the once great Indian nations. At best he was indifferent. Russell, on the other hand, was, like Catlin, an active proponent of the Native American cause. His contempt was reserved for the farmers, whom he vilified as "nesters," and for the tourists who by 1900 were swarming through the Montana countryside.

With Remington and Russell the artistic saga of the golden West largely comes to an end. Others would continue to paint and sculpt the legendary figures, but, unlike their predecessors, they would never see a buffalo hunt, a cattle drive, or an Indian raiding party. The West that was is long gone. All that remains is the art.

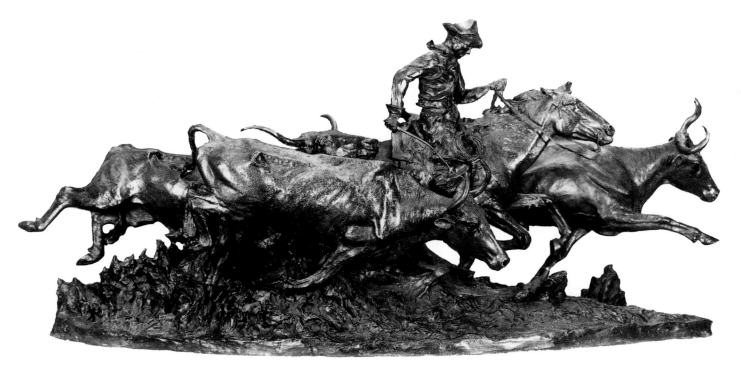

The Stampede

FREDERIC S. REMINGTON

1910, bronze. Frederic Remington

Art Museum, Ogdensburg, New York.

The power and fluidity of Remington's group sculpture dramatically captures the terror of an out-of-control herd of cattle.

Cowboy Camp during the Roundup

CHARLES M. RUSSELL

detail; c. 1885–1887; oil on canvas. Amon Carter Museum, Fort Worth, Texas.

This detail shows Russell's signature and the buffalo skull logo which appears in many of his works. Like everyone in the painting, the two cowboys, "Kid Antelope" (about to lose his seat) and Charlie Carthare, are recognizable as companions of the artist.

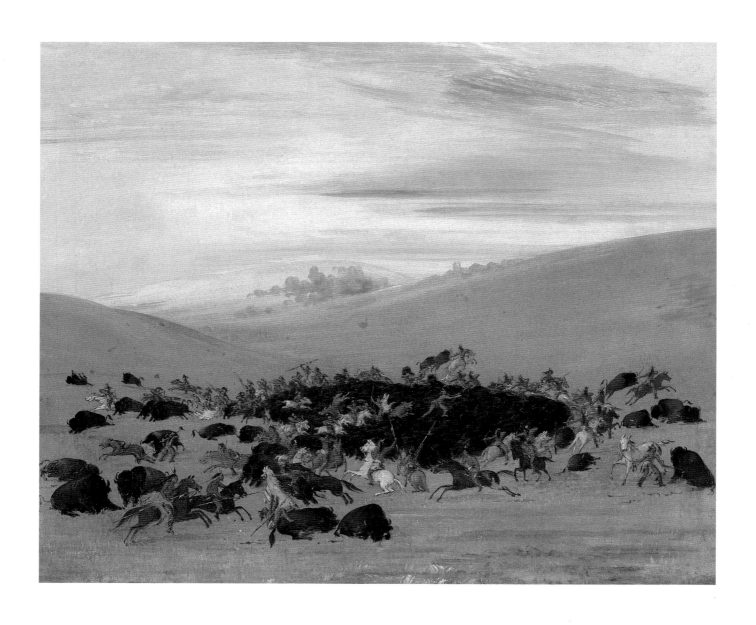

Buffalo Chase: A Surround by the Hidatsa

GEORGE A. CATLIN

c. 1832–1833, oil on canvas. National Museum of American Art/Art Resource.

Though they lived along the Missouri, the Hidatsa ranged
as far west as the Rocky Mountains in pursuit of buffalo.

GEORGE CATLIN AND HIS INDIAN GALLERY

By far the most remarkable of the early painters of Western scenes and visages was George Catlin (1796–1872). Not only was Catlin the first artist of stature to visit the great prairies but he was also one of the first Americans to anticipate the inevitable destruction of the native inhabitants and wildlife and to call upon the federal government to establish a system of natural parks to preserve this unique culture. Though he failed in this latter goal (a failure inevitable given the contemporary political climate), he left behind a documentary record, both written and pictorial, that has proven invaluable.

Born at Wilkes-Barre, Pennsylvania, on July 26, 1796, George Catlin—unlike many other painters of the West, who were European—came of long established colonial stock. His great-great-great-great grandfather had settled in Hartford, Connecticut, in 1644 and his father, Putnam, fought in the Revolutionary War. Catlin's mother, Polly Sutton, was captured by Indians during the terrible Wyoming Valley, Pennsylvania, massacre of 1778, and was later ransomed.

Putnam Catlin was a lawyer but after a few years' practice in Wilkes-Barre he settled his growing family on a farm in New York State in the Susquehanna Valley region. Young George grew up listening to his mother's tales of life with the Iroquois and hunting and fishing in what was then a largely undeveloped territory in the east. Like other, later Western artists (such as Remington

and Russell) Catlin resisted formal education. Sent to train at the famous Gould and Reeve law school in Litchfield, Connecticut, he returned home to practice fitfully. But by 1821 he had largely abandoned the law and had become a locally respected portrait painter. There is little doubt that, had he chosen to, Catlin could have spent a comfortable life painting likenesses of the eastern gentry.

He was certainly both proficient and well connected. While sharpening his skills in Philadelphia during 1823 he was an intimate of such illustrious artists as Rembrandt Peale and Thomas Sully. A year later he was elected a member of the Pennsylvania Academy, and two years after that, an Academician of the National Academy, honors other artists had waited a lifetime for. Moreover, by this time Catlin had painted miniature portraits of illustrious people, such as statesmen DeWitt Clinton and Oliver Wolcott.

However, as an artist Catlin cared little for this. His spirits inflamed by the sight of a visiting delegation of Plains Indians, he decided to devote his life to documenting the Western tribes. As he later noted in his *Letters and Notes on the Manners, Customs and Conditions of the North American Indians* (1841): "... the history and customs of such a people, preserved by pictorial illustrations, are themes worthy of the life-time of one man, and nothing short of the loss of my life shall prevent me from visiting their country, and becoming their historian ..."

GONE WEST

Catlin, as events proved, was a fanatic, a man obsessed with his dream of documenting life in the West. Otherwise, he could not have undertaken and withstood the hardships that lay in store. Married in 1828 to Clara Bartlett Gregory, a woman of means, he found that he could not count on her family's support. His own income had been entirely dependent upon portrait painting, a pursuit he abandoned. As a result the artist undertook his great project with limited funds.

Nevertheless, he went forward. Armed with letters of introduction from Washington friends, in the spring of 1830 he traveled to St. Louis, Missouri, where he contacted the renowned General William Clark. Clark, now Superintendent of Indian Affairs, arranged for Catlin to paint portraits of various Indian dignitaries visiting the city, which was then the point of departure for the entire Western territory. More important, Clark allowed the artist to accompany him on several tours into Indian territory, including the upper Mississippi River, Fort Leavenworth, and west to the Kansas River. Here, Catlin came in contact with representatives of the Western tribes and painted several notable portraits, including that of the famous "Shawnee Prophet," Ten-squa-ta-way (the open door), brother to Tecumseh.

It is important at this point to bear in mind that St. Louis was then on the very border of practically unknown territory. Though traders had penetrated the Rockies some years before and settlements were beginning to spread up the Missouri River, practically nothing was known in 1830 of the Western interior. Tens of thousands of Native Americans, most of whom had never seen a white man, lived here, for the moment largely undisturbed. It was the lives of these people George Catlin wished to document.

After spending the winter with his wife, Catlin returned west in the spring of 1831, joining Major John Dougherty in a trip of uncertain length up the Platte River through the present day state of Nebraska, penetrating, perhaps, as far west as Fort Laramie in Wyoming. Along the way he visited and painted members of the Omaha, Otto, and Pawnee nations, including Om-pah-ton-ga (Big Elk), principal chief of the Omaha.

To this point the artist had largely confined himself to paintings of individual Indians, primarily high ranking individuals. In 1832 Catlin began to sketch and paint tribal activities and to maintain detailed notebooks documenting his experiences as well as augmenting his growing collection of Native American artifacts—clothing, weapons, religious paraphernalia, and the

**St. Louis from
the River Below**

GEORGE A. CATLIN

*c. 1832–1833, watercolor on
paper. National Museum of
American Art/Art Resource.*
By 1832 St. Louis, "the
gateway to the West,"
was one of the largest
cities in the United States,
and steamboats, like
the *Yellow Stone* depicted
here, were opening the
Missouri River to trade.

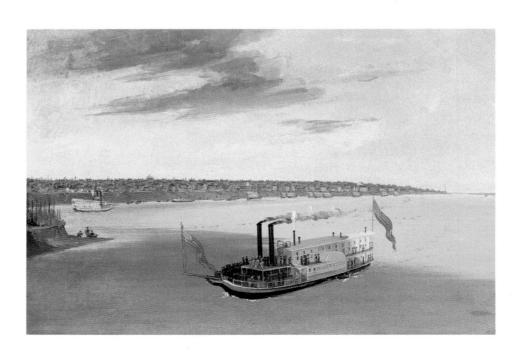

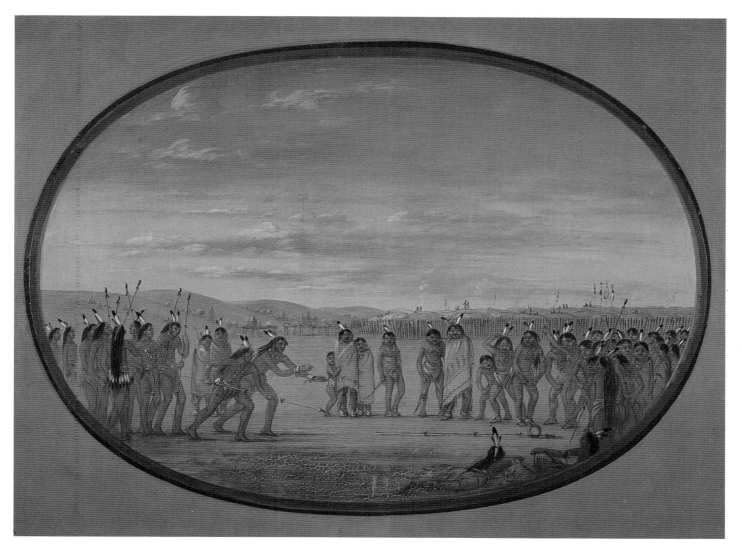

Game of Tchungkee

GEORGE A. CATLIN

1832, watercolor on paper. American Museum of Natural History, New York.

As a relatively sedentary tribe, the Mandan had more leisure time, much of which was employed in games such as Tchungkee, which involved casting spears at a rolling hoop.

like. All these elements were to form the basis for what he would term his Indian Gallery: a project which was to consume his energies for the remainder of his life.

With Catlin among the passengers, the 1832 expedition began by steamboat—the *Yellow Stone,* the first vessel to travel the 2,000 miles (3,218 kilometers) of the Missouri River that lay between St. Louis and Fort Union in Montana. After some 1,200 miles (1,930 kilometers) of river travel, the boat stopped to await higher water and Catlin joined a trading party traveling west to what is now the vicinity of Pierre, South Dakota. There he encountered for the first time the mighty Sioux, or Dakota, nation whose domain then stretched from the upper Mississippi as far as the Rocky Mountains. The artist was duly impressed, describing them as "... fine and prepossessing,

tall and straight, and their movements graceful."

It was also here that Catlin ran into a difficulty many artists and photographers have experienced when portraying the images of primitive peoples. The Sioux had never seen a portrait. Catlin's first effort, a painting of their chief Ha-wan-je-tah (One Horn) was met with a mixture of dread and admiration, the former increasing when an envious medicine man pointed out that as the chief's eyes were open in the painting, he

no doubt would never be able to sleep again! It was with no little difficulty that the artist and his companions convinced the tribe that the painting was an honor which would bring distinction, not harm, to the sitter. And this was not Catlin's last brush with this problem. On the other hand, pleased sitters often would lie for hours admiring their portraits and guarding them against harm. Dubbed the Medicine Painter (Ee-cha-zoo-kah-wa-kon), Catlin soon became a legend on the prairies, a much admired though somewhat feared guest.

ANTHROPOLOGIST AND ARTIST

George Catlin was an ethnographer as well as an artist. He was determined to capture not only the exact details of costume and appearance but also the important daily activities of his hosts. The appearance and dress of the Native American tribes astounded white viewers who, if they had seen Indians at all, were familiar only with those of the assimilated reservation and border tribes. Even more shocking to them were Catlin's render-

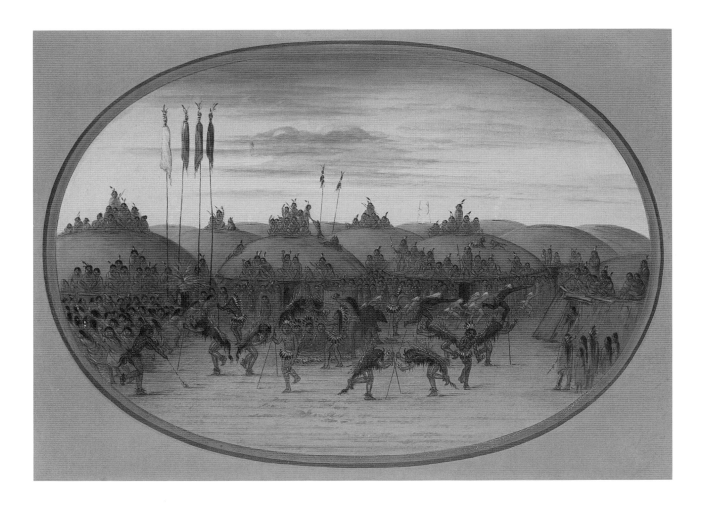

Mandan Bull Dance

GEORGE A. CATLIN

1832, watercolor on paper. American Museum of Natural History, New York.

Like all Plains Indian tribes, the Mandan had ritual
dances and ceremonies designed to promote success
in hunting the Bison and other animals.

ings of rituals, such as the Bear, Beggars', and Scalp Dances, and the torture ceremonies such the Sioux' "Looking at the Sun" and the Mandan O-Kee-Pa, both designed to test a young brave's endurance and prove his tribal worth.

Catlin was also the first to illustrate those activities which framed the Native American life—the highly organized hunts for the buffalo upon which the tribes depended not only for food but for many other necessities as well; the constructing of tee-pees; the seasonal treks to their hunting grounds; the daily chores of the women; and the games (such as archery contests and a ball game from which is derived modern day lacrosse).

Though accused in his day of being a "romantic," primarily for his spirited defense of native peoples against white encroachment, Catlin was a most pragmatic and conscientious chronicler of Indian life. Ironically, this would prove harmful to the subjects themselves, whom he truly cared for. The outlandish (to white eyes) costumes and seemingly cruel customs of the Western tribes

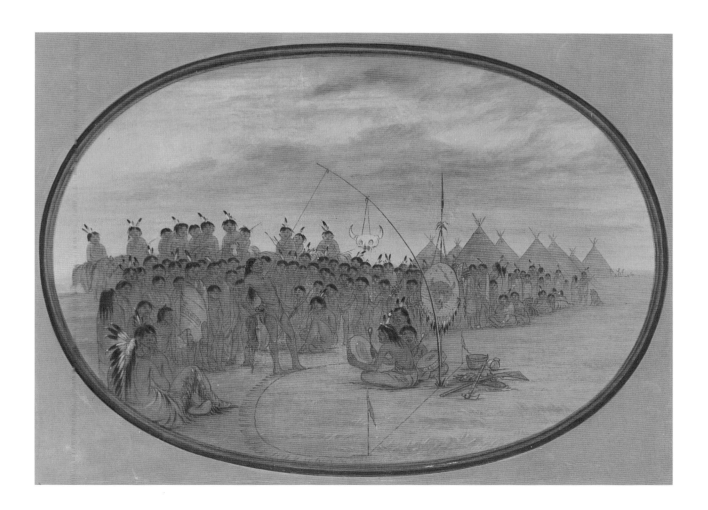

Looking at the Sun

GEORGE A. CATLIN

1832, watercolor on paper. American Museum of Natural History, New York.

The Mandan torture rituals, which were designed to test a young brave's
readiness for adult responsibilities, were so horrific to whites that
many refused to believe Catlin had really seen and documented them.

Indians Attacking the Grizzly Bear

CURRIER & IVES, AFTER A WATERCOLOR BY GEORGE A. CATLIN

c. 1834, lithograph. Nawrocki Stock Photo, Chicago.

While the Bison was hunted for meat, bear hunting was primarily a sport indulged in by both Native Americans and whites, including members of the 1804 Lewis & Clark expedition.

Comanche Lodge of Buffalo Skins

GEORGE A. CATLIN

c. 1834–1835, oil on canvas. National Museum of American Art/Art Resource.

Famed horsemen and feared warriors, the Comanche ranged over much of northern Texas and northeast into Kansas, posing a threat to white expansion in this area.

served to justify an indifference to their fate.

After some time Catlin returned to the *Yellow Stone,* which proceeded north to Fort Union where he encountered and painted subjects from the Blackfoot and the Crow nations. Throughout the summer the artist wandered alone among the camp sites of these peoples, hunting with them, sketching them at their daily work and play, and sharing a life that was both arduous and dangerous. With the exception of Father Nicolas Point, no other painter of the West ever lived so close to his subject matter.

Then in the fall Catlin embarked on another extraordinary adventure. Accompanied by two trappers for the American Fur Company he paddled a canoe 2,000 miles (3,218 kilometers) down the Missouri River to St. Louis. The highlight of their surprisingly uneventful trip was a stop at the village of the Mandans, a sedentary hunting and agricultural tribe living in domed wood and earth dwellings on the river near present-day Bismarck, North Dakota.

One of the most important Mandans painted by Catlin was Mah-to-toh-pa (Four Bears), second chief and an artist in his own right as well as the gracious host of the Lewis and Clark expedition in 1806. Though numbering only about two thousand the Mandan had developed a sophisticated society and complex religious rituals, including the terrifying O-Kee-Pah, or torture ceremony. Catlin is the only white man known to have witnessed this ceremony, and his drawings are all that remain to document it as the tribe was wiped out in 1837 by white-introduced smallpox.

Leaving here, Catlin and his companions paused for some time with the neighboring Minnetarees or Hidastas, then slid past a village of the Arikaras who were at this time hostile to whites, and after brief stays with the Ponca, Ioways, and Omahas reached Fort Leavenworth on the Missouri just north of Kansas City, where he painted members of the powerful Pawnee tribe. Shortly thereafter the group reached St. Louis. During the season Catlin had painted some 135 pictures and acquired a variety of Native American artifacts.

After a year exhibiting some of his work in St. Louis and Cincinnati, the year 1834, found the artist once more on the prairies, this time travel-

ing into the Southwest in the company of the first American military expedition to explore what was then Mexican territory. Starting at Fort Gibson on the Arkansas River (where he sketched members of the newly resettled Cherokee, Creek, and Choctaw nations) Catlin and his group journeyed into the wild and desolate southwestern desert where the artist exulted that: "I am going farther to get sitters than any of my fellow artists ever did, but I take an incredible pleasure in roaming through nature's trackless wild and selecting my models where I am free and unshackled by the killing restraints of society . . ." Catlin came to regret these words, for he and most of the company soon fell ill, and the journey became a deadly nightmare. Indeed, only the generous assistance of the Comanche and later the Pawnee enabled the troop to survive its harrowing journey. Over a third had died of illness during the expedition. Then, though not yet fully recovered, he rode 500 miles (804 kilometers) alone to St. Louis.

After a winter recuperating in Florida, the artist turned west again in 1835. This time accompanied by his wife, he took a steamboat up the Mississippi to Fort Snelling (near present-day St. Paul, Minnesota) where he was able to paint the Sauk and Fox and Chippewas. Then, after sending his wife south by boat, Catlin embarked on another pilgrimage, a canoe trip of 900 miles (1,448 kilometers) downriver to St. Louis.

Though the artist reported the trip as fairly uneventful, he did describe one incident which indicates what sort of man Catlin was. Just south of Fort Snelling he and his companion were shot at by drunken Sioux. Anyone else would have paddled for his life. Not Catlin. He stormed ashore armed with rifle and pistols and forced the Indians to pose for him. Having finished the sketches and harmed no one, he then proceeded on his way. Finally, in 1836, he journeyed through Wisconsin to visit a quarry in southwest Minnesota where the red limonite, or pipestone, used to make tribal pipes was mined; he was the first non-Native American to do so.

END OF THE TRAIL

The Western saga, however, was coming to an end. Still nearly penniless, Catlin had again exhibited

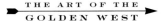
Ball Play Dance

GEORGE A. CATLIN

1844, watercolor on paper. Nawrocki Stock Photo, Chicago.
Like much of Indian life, ball playing had a
ritualistic aspect. Here costumed contestants
take part in a dance honoring the competition.

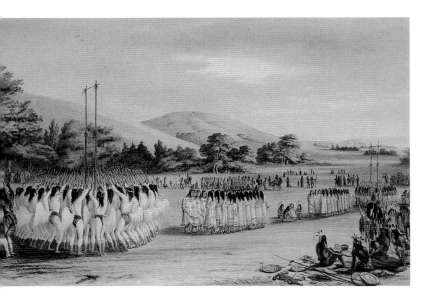

his Indian Gallery, this time in Buffalo, New York, in July of 1836. Encouraged by the public reception, he decided upon a major tour. It opened in Albany, New York, in May of 1837, proceeding thereafter to nearby Troy and, finally, to New York City in September of the same year and to Washington, D.C. in 1838. Everywhere the response was the same—an initial enthusiasm followed by declining interest and box office receipts.

Catlin, meanwhile, had been trying to convince the federal government to buy his entire collection as the foundation of a national museum. But the time was not yet ripe for this ambitious project (finally realized in the Smithsonian Institution). Moreover, the artist's unflinching support for the Native American cause had angered the many who favored extirpation. A resolution for purchase introduced in Congress during the 1837–1838 session was not acted upon.

Desperate, Catlin took his family and the Indian Gallery to Europe. Exhibitions in England (1840–1844) and Paris (1845–1848) followed the same course; initial enthusiasm, then disinterest.

The artist's world crashed down around him. His wife and son died. Creditors seized much of his collection. His in-laws took away his three remaining children. Still, Catlin continued to work. He wrote several monographs on his travels and produced numerous paintings and engravings based on his original sketches. Meanwhile, in Washington, a bill for purchase of Catlin's Indian Gallery was finally brought to a vote. Despite the pleas of distinguished supporters like Daniel Webster it failed to pass, largely due to the political backbiting of a talentless pettifogger named Henry Rowe Schoolcraft, whom Catlin had offended by refusing to allow his art to be used by the ethnologist in his pedestrian "study" of Indians of the West.

In the midst of all this disaster, the artist grasped at yet another straw. He would travel to South America and paint the aborigines there. Slipping away from Paris in 1853 he journeyed to Brazil and spent the years 1853–1858 traveling and sketching throughout the continent. The artist returned to Europe in 1858, residing in Brussels and writing several other important illustrated books including *Life Amongst the Indians* (1861) and *Last Rambles Amongst the Indians* (1868).

But Catlin was growing old and, since the age of fifty, he had been largely deaf. In 1870 he returned to the United States where, in 1871, his latest work, "Catlin's Indian Cartoons," was exhibited at the Smithsonian—a lifelong dream realized. He died a year later while Congress yet debated the purchase of his paintings. Ironically, his first and greatest Indian Gallery finally was sold to the Smithsonian in 1879 (by the heirs of a creditor), while the "cartoons" were purchased by New York's Museum of Natural History in 1912 from his last surviving daughter. With his fame as an artist and ethnographer secured and his work hanging in major collections, Catlin's greatest hopes were finally fulfilled.

Champion Choctaw Ball-Player

GEORGE A. CATLIN

1844, watercolor on paper. Nawrocki Stock Photo, Chicago.
Forerunner of today's lacrosse, ball playing was popular
with most Plains tribes. The games often involved
hundreds of players and went on for hours at a time.

Junction of the Yellowstone
and the Missouri

KARL BODMER

1833, watercolor on paper. Joslyn Art Museum,
Omaha, Nebraska.

Landscapes by the early western artists are
relatively uncommon. They were more interested
in portraits and genre scenes of Indian life.

BODMER AND MILLER, ARTISTS FOR HIRE

George Catlin's financial struggles reflect the difficulty an artist lacking independent means had in painting in the West. Transportation costs, guides, provisions, and the inevitable but essential Indian gifts amounted to a substantial, indeed daunting, outlay. However, there was a way around the problem—the age-old European tradition of patronage. It was through this means, the wealthy patron, that two of Catlin's most immediate successors, Karl Bodmer and Alfred Jacob Miller, found their way to Indian Territory.

KARL BODMER

Karl Bodmer (1809–1893) was born in Switzerland and trained as an artist in Paris, where he came under the influence of romanticist Eugène Delacroix and where, later in life, he was an important member of the Barbizon school of artists. As a highly skilled professional (but with no great interest in the American West), Bodmer came to the attention of Prince Maximilian of Wied-Neuwied, who was both wealthy and an accomplished naturalist. Maximilian was planning a trip to the upper Missouri and needed an illustrator.

An agreement was reached, and in 1832 the prince's party arrived in Boston, pushing on to New Harmony, Indiana, where they spent the winter. In the spring of 1833 at St. Louis they embarked upon the *Yellow Stone,* the same steamer that had transported Catlin but a year before. Reaching Fort Union, they transferred to keel boats and pushed on up the shoaling Missouri to the American Fur Company's Fort MacKenzie. This was Blackfoot territory and well beyond Catlin's furthest penetration.

After two months among Indians and fur traders the party returned down river to the native settlements near Fort Clark where the winter was spent among the Mandan and Minnetaree. The following spring they returned to Europe. It was Bodmer's only trip to the United States. His role as illustrator is reflected in the appended "Atlas" of engravings in Maximilian's *Reise in das innere Nord-Amerika in Jahren 1832 bis 1834* ("Journey in inner North American, 1832–1834"), published in 1839 and regarded as a definitive work on the period.

Bodmer's knowledge of the Western tribes cannot be compared to that of Catlin. He spent less than a year among them, and whereas Catlin knew and illustrated nearly fifty different cultures, it is doubtful that Bodmer came in contact with much more than a dozen. On the other hand, Bodmer was a highly trained professional artist, a brilliant

FOLLOWING PAGE:

Breakfast at Sunrise

ALFRED JACOB MILLER

1837, watercolor on paper. Walters Art Gallery, Baltimore, Maryland.
A group of trappers, hunters, and Native Americans
gathers for a meal in the early morning. Miller was
at his best in accurately portraying such genre scenes.

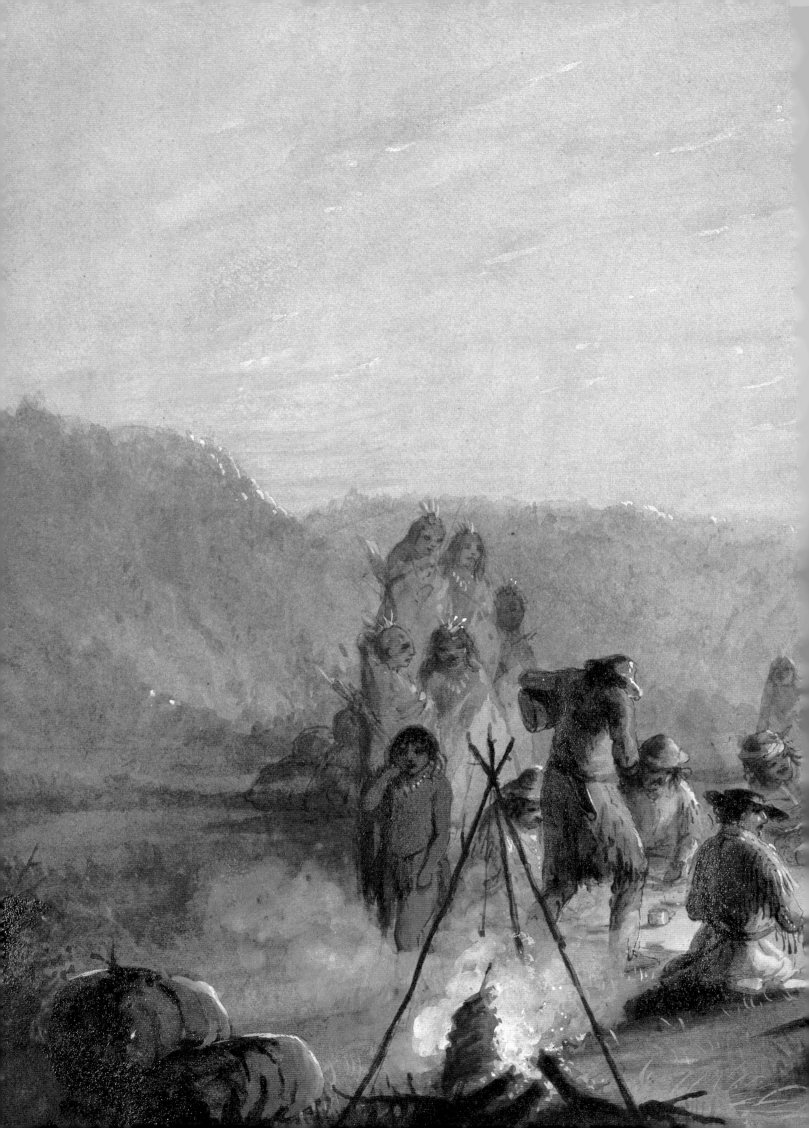

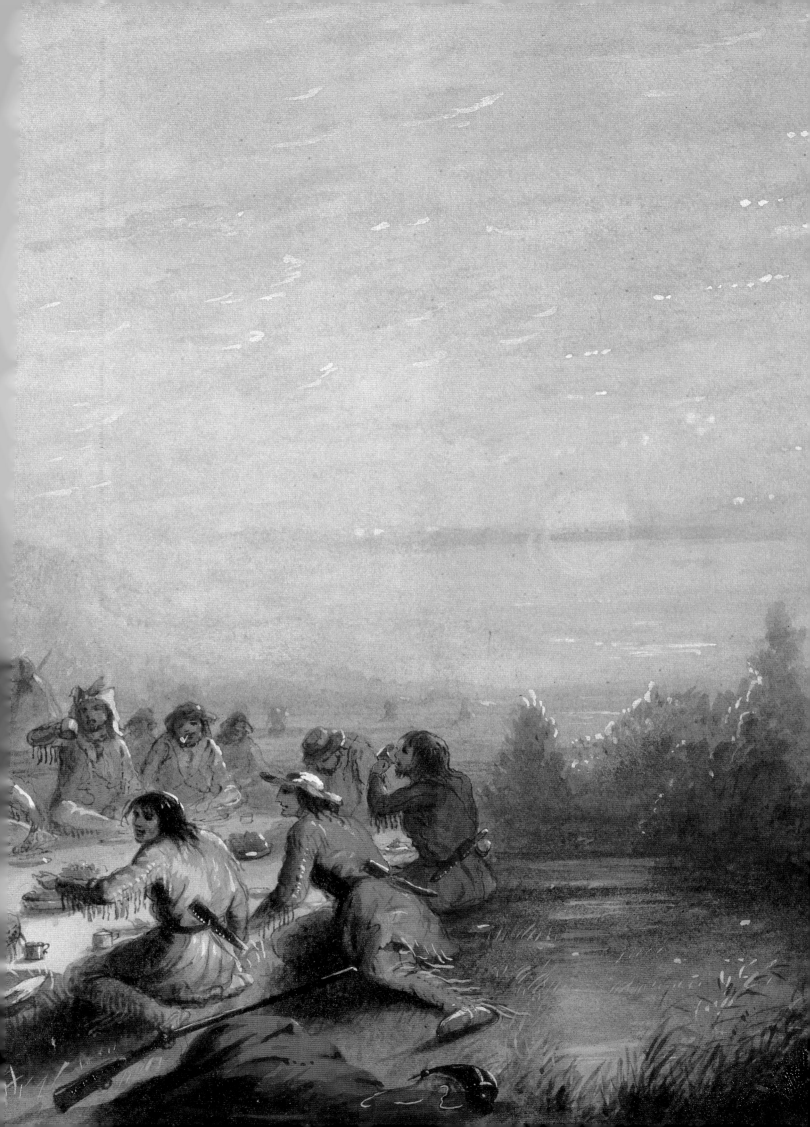

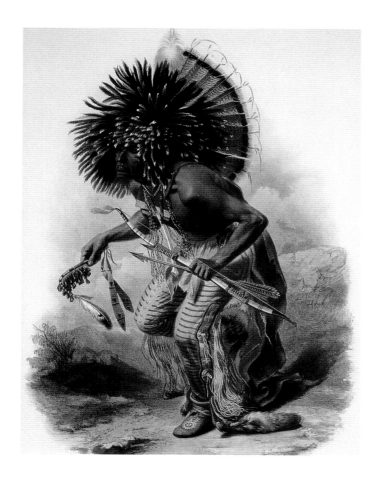

draftsman with remarkable powers of observation. As Bernard DeVoto notes in *Across The Wide Missouri*: ". . . [t]hese paintings have the focus and selectivity of medical art, the illustration of anatomy or surgical technique by drawing, which permits a clarity, emphasis and separation of parts and planes beyond the capacity of the camera lens."

Bodmer worked in watercolors since his sketches were to be rendered as hand-colored engravings. His paintings are remarkably lifelike; yet, true to his European training, he often toned down and harmonized the strident, clashing color combinations of which his native hosts were so fond.

Bodmer depicted not only individuals—Indians, trappers, guides, and scenes of Native American life—but also landscapes. The best, such *as Junction of the Yellowstone and the Missouri Rivers* and *View of Fort Union,* are not only among the earliest Western landscapes (Catlin did but few, and poorly) but are also often more faithful to nature than those produced by the later landscape artists of the West. Moreover, Bodmer dealt as effectively with the problems of the West's vast spaces and intense light as any pre-Impressionist artist.

Pehriska-Ruhpa Minatarre Warrior in the Costume of the Dog Dance

AFTER A PAINTING BY KARL BODMER

c. 1834–1837, colored engraving.

Joslyn Art Museum, Omaha, Nebraska.

Like Catlin, Bodmer was able to paint the western tribes before their dress had been influenced by white settlers and adventurers.

Herd of Bison on the Upper Missouri

AFTER A PAINTING BY KARL BODMER

c. 1834–1837, colored engraving.

Joslyn Art Museum, Omaha, Nebraska.

Many artists painted the Bison herds, but few captured them in such a dramatic landscape.

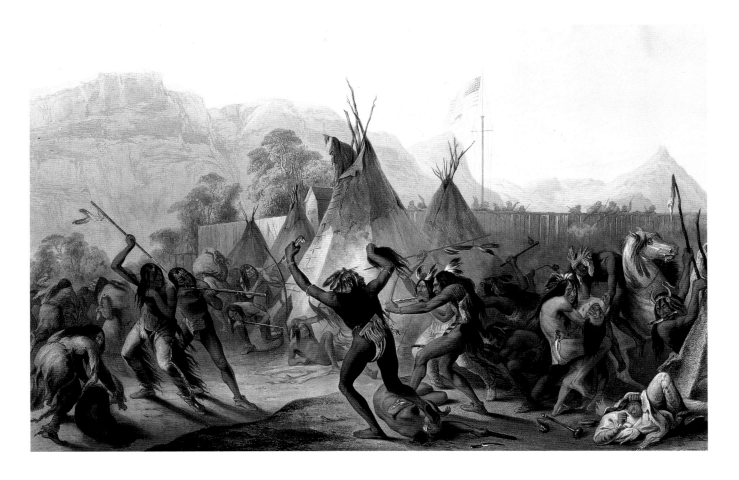

Fort MacKenzie, August 28th, 1833

AFTER A PAINTING BY KARL BODMER

c. l834–l837, colored engraving.

Joslyn Art Museum, Omaha, Nebraska.

Bodmer witnessed and recorded this
violent encounter between two tribal groups
camped outside Fort MacKenzie in 1833.

Fort Union on the Missouri

FROM A PAINTING BY KARL BODMER

c. 1834–1837, colored engraving.

Joslyn Art Museum, Omaha, Nebraska.

Like other early western citadels, Fort
Union functioned both as a refuge and as
a combined trading post and general store
servicing tribes from the surrounding area.

ALFRED JACOB MILLER

Another disciple of Delacroix, transplanted to the American West, was Alfred Jacob Miller (1810–1874). Though of native birth, Miller showed even less initial interest in the great frontier than had Bodmer. However, he too found his calling there.

Born in Baltimore, Miller showed an early artistic aptitude. After study with the portrait painter Thomas Sully, he was taken under the wing of a wealthy Baltimore patron of the arts who arranged for him to study in Paris and Rome, where he was greatly influenced by the Romantic movement. Returning to the United States in 1834, he established a studio in New Orleans.

It was there, some three years later, that he was found by the wealthy Scottish baronet, Captain William Drummond Stewart. Stewart had spent the past four summers in the Rocky Mountains and was keen to return again, this time with an artist to record his adventures for eventual installation as paintings in his family manse, Murthly Castle. Miller had been getting along as a portrait painter, but the Captain's offer was too good to refuse. In 1837 he joined Stewart's party, which was allied to a group of fur traders traveling up the Platte River to the Rocky Mountains and then pushing forward to the Tetons in present-day Wyoming and Idaho.

It was an extraordinary trip, presenting Miller with the opportunity of being the first artist to paint in the Rocky Mountains (Catlin's claims of having reached this area in 1833 were dubious). As a result, we owe to Miller not only views of such Western landmarks as Chimney Rock, Devil's

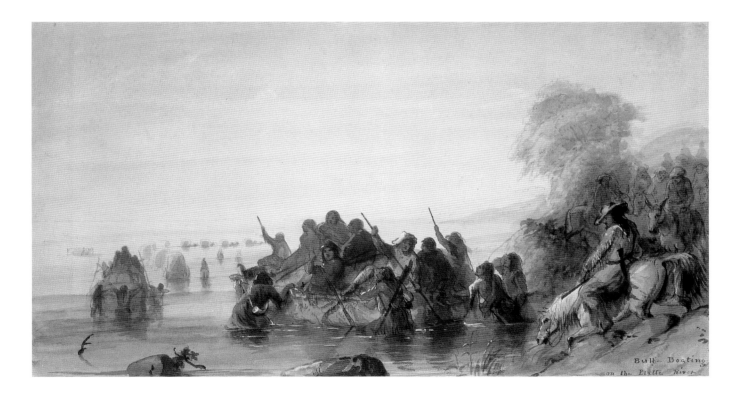

Bull Boating on the Platte River

ALFRED JACOB MILLER

1837, watercolor on paper. Joslyn Art Museum, Omaha, Nebraska.

Bull boats, made from Bison hide were commonly used on the Platte, an unusually shallow stream once described as being ". . . a mile wide and a foot deep."

Antoine Clement, the Great Hunter

ALFRED JACOB MILLER

1837, oil on canvas. Walters Art Gallery, Baltimore, Maryland.

Clement, of French extraction and heir to the great voyageur tradition, was a noted hunter and fur trapper.

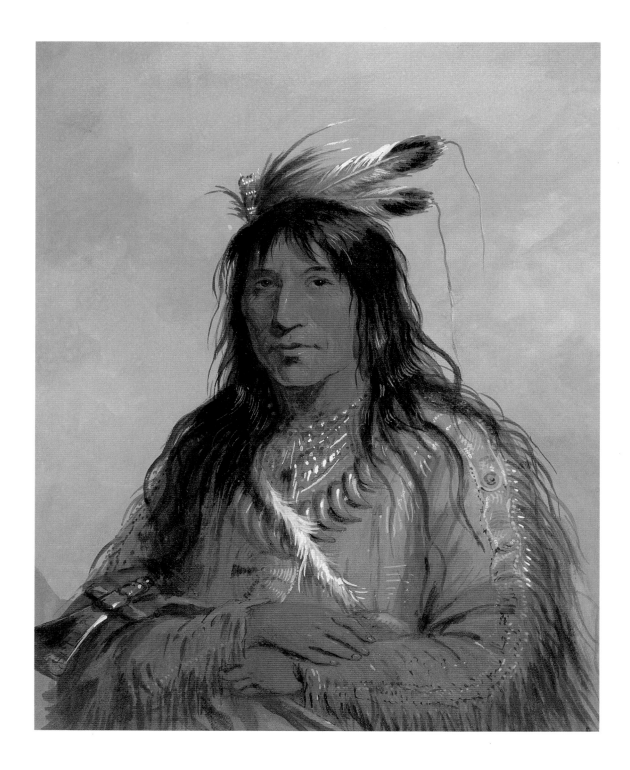

Bear Bull, Chief of the Oglala Sioux

ALFRED JACOB MILLER

1837, watercolor on paper. Walters Art Gallery, Baltimore, Maryland.

Bear Bull wears the bear claw necklace symbolic of a
great warrior in a culture where the highest distinction
went to one who had killed a bear in single combat.

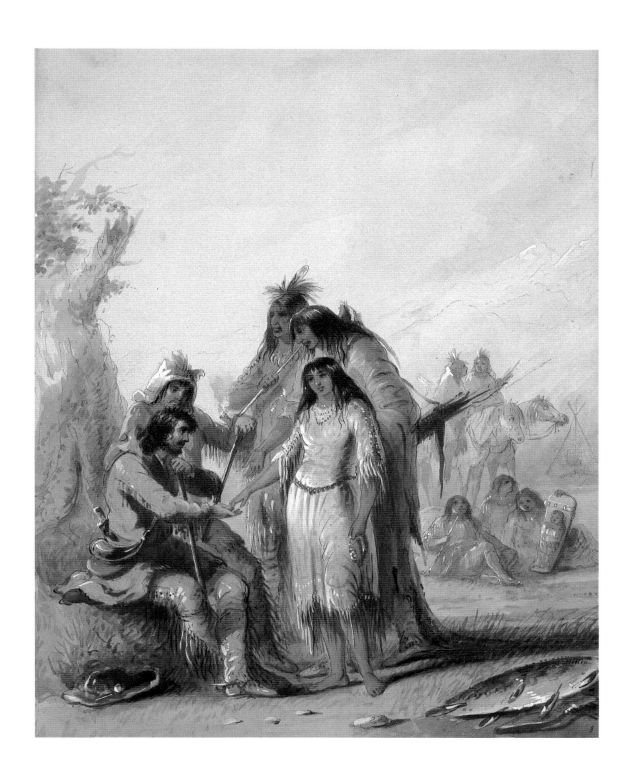

The Trapper's Bride

ALFRED JACOB MILLER

1837, watercolor on paper. Walters Art Gallery, Baltimore, Maryland.

Many trappers and mountain men, as well as artist

Seth Eastman, took native brides and raised families.

Sadly, their offspring were often scorned as "half-breeds."

Gate, and Independence Rock but also a painting of one of the last of the legendary fur traders' rendezvous held each July on Utah's Green River.

Miller's portraits of trappers and traders are especially important because at the time he went west the trade, primarily in beaver pelts, was dwindling. Legendary trappers like Jim Bridger and Kit Carson had scoured the mountains since the 1820s, and declining beaver stocks combined with changes in European fashions brought the rendezvous to an end only two years after Miller happened upon the scene.

During his summer in the mountains the artist produced over 150 watercolors and sketches cov-ering a variety of topics—landscapes, Indian life, and, of course, buffalo hunts. Miller, unlike the intrepid Catlin, was not a hunter, and his sketching of the great buffalo herds could involve some risk. It appears, in fact, that Miller was the classic "tenderfoot." He hated horses, particularly having to run them down in the morning after they had been allowed to feed overnight, hired others to stand his night watches, and was upbraided by Captain Stewart for his general lack of martial spirit, a deficiency the Scot credited to his not having "been brought up right."

He survived the year, and in 1840 traveled to Scotland to paint a group of large oils taken from

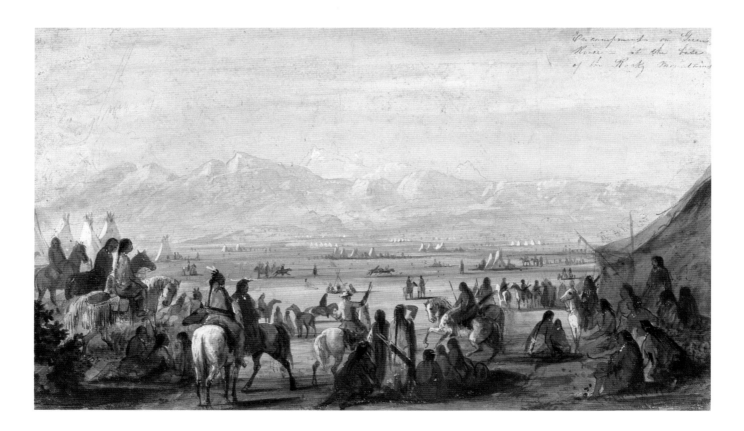

Encampment on Green River

ALFRED JACOB MILLER

1837, watercolor on paper. Joslyn Art Museum, Omaha, Nebraska.

Each July, for nearly twenty years, fur traders and Indians gathered on
Utah's Green River to trade, resupply, and have a good time. Miller captured
this scene just two years before the rendezvous came to an end.

sketches made on the trip. Though they appear to have pleased his patron, these monumental works have generally been regarded by critics as less successful than Miller's spontaneous sketches.

Miller remained abroad for two years, working for Stewart and painting portraits both in Scotland and in England. He also ran into Catlin, meeting him in London in 1842. The two artists may not have hit it off, for in a letter to his brother Miller remarked that ". . . there is a great deal of humbug about Mr. George Catlin . . ." However, while Miller was enjoying the favor of a rich patron Catlin was scrambling to support his family and his dream.

Miller returned to Baltimore the same year and settled down to a comfortable life as portrait and genre painter. He also turned out a substantial number of "Indian paintings" for the local trade. While some of these were based on his Western sketches, others appear to owe their origin to popular literature or as illustrations for current themes like Indian massacres, mining, and buffalo hunting. Some of the more romantic of these, such as *The Trapper's Bride*, sold so well that the artist reproduced them several times for several customers. Miller showed no interest in ever going out West again. His one trip had provided him with a lifetime's material.

Landing the Charettes

ALFRED JACOB MILLER

1837, watercolor on paper. Walters Art Gallery, Baltimore, Maryland.

Travel in the undeveloped West was arduous as well as
dangerous. Here, Miller portrays the moment when
a group of horse-drawn wagons is fording a river.

The Lost Greenhorn

AFTER A PAINTING BY

ALFRED JACOB MILLER

1851, chromolithograph. Buffalo Bill

Historical Center, Cody, Wyoming.

Here Miller captures the
neophyte, constant butt of
the hardened travelers' jokes,
as he tries desperately to find
his way back to civilization.

Devil's Gate

ALFRED JACOB MILLER

1837, watercolor on paper. Walters

Art Gallery, Baltimore, Maryland.

This narrow passage was just
one of the many hazards faced by
overland travelers in the West.

THE NEXT WAVE

From the late 1830s into the 1850s other artists made their way West determined to chronicle the American dream of expansion to the Pacific. Some, like Seth Eastman (1808–1875), spent considerable periods of time in the area. Unlike most of his contemporaries, Eastman actually lived on the prairies. A West Point graduate, he was assigned to Fort Crawford and Fort Snelling in Michigan Territory in 1831, remaining there for some two years before reassignment and eventual duty as drawing master at West Point. In 1841 he was back at Snelling (near present-day Minneapolis), where he remained for the next seven years. There he learned the Santee Sioux language and fathered a daughter with his tribal mistress.

SETH EASTMAN

Like Catlin, Eastman was truly interested in the Native American way of life. He understood it and with his draftsman's skills portrayed it accurately and straightforwardly. In fact, it was Eastman that Henry Schoolcraft (having been rejected by Catlin) chose to illustrate his six-volume *Indian Tribes of the United States*. This group of paintings, done while Eastman was assigned to the Bureau of Indian Affairs in Washington, D.C., during the 1850s, remains the best thing about Schoolcraft's ponderous work.

Though a military man, the artist seldom painted scenes of warfare. The four hundred or so sketches and paintings he did in the West are almost exclusively genre scenes, representations of daily life among the traders and tribal groups frequenting the Fort Snelling area. He would often photograph a bit of daily business, a ceremony, or native gathering and then render it in a manner both artistic and accurate.

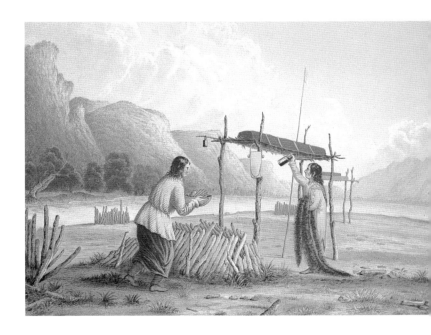

Ballplay of the Sioux on the St. Peters River in Winter

SETH EASTMAN

detail; 1848, oil on canvas. Amon Carter Museum, Fort Worth, Texas.

This detail shows the violent action in a game which, in its competitive intensity, often verged on warfare.

Indians Offering Food to the Dead

AFTER A PAINTING BY SETH EASTMAN

c. 1841–1847, chromolithograph. Buffalo Bill Historical Center, Cody, Wyoming.

Eastman, who lived among the Sioux in Minnesota for some years, understood and appreciated Native American rituals such as this one honoring the dead.

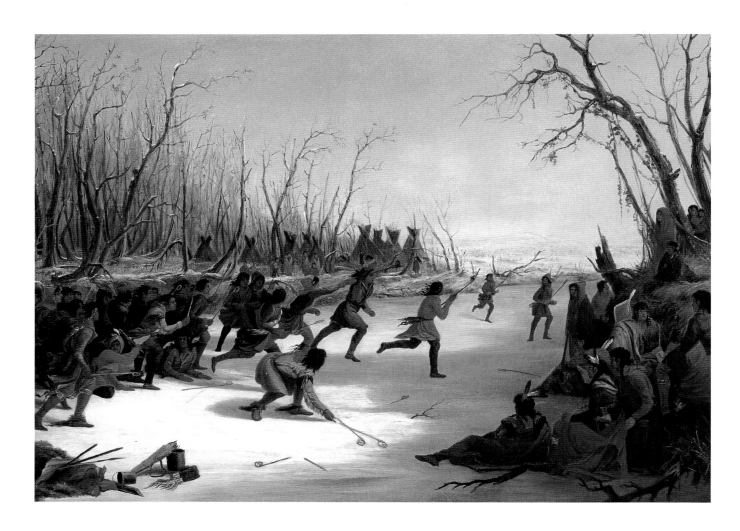

Ballplay of the Sioux on
the St. Peters River in Winter

SETH EASTMAN

1848, oil on canvas. Amon Carter
Museum, Fort Worth, Texas.

Eastman, an army officer stationed in the
Michigan Territory for long periods, knew
the Sioux as well as any artist of his time.

That Eastman's privileged relationship to his sub-
jects did not come without a price is reflected in an
unsuccessful petition submitted to Congress by his
widow seeking reimbursement for what we would
now term photography costs. She noted that he
had been: "obliged to purchase from the Indians
their dresses and utensils, and to pay them also for
the privilege of painting their customs and cere-
monies from life . . . and also to pay Indians who
assisted him to persuade others to consent to the

FOLLOWING PAGE:

Sioux Indians

SETH EASTMAN

1850, oil on canvas. Joslyn Art Museum, Omaha, Nebraska.

Like Catlin and Bodmer, Eastman was a student of Native American life and accurately portrayed his subjects' domestic activities.

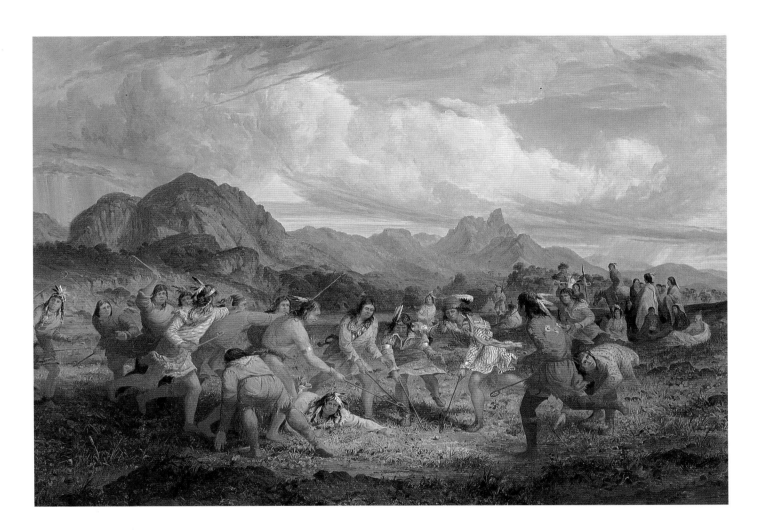

representation of customs they deemed sacred."

Though Eastman's work was often highly praised (a critic for the *Missouri Daily Republican* declared in 1848 that ". . . we have ranked him as out of sight the best painter of Indian life the country has produced . . ."), it seldom sold. Nor did the artist make any great effort to promote his paintings. Fortunately, he did not have to rely upon painting as a source of income, remaining active in the military until late in life.

Lacrosse Playing among the Sioux Indians

SETH EASTMAN

c. 1841–1847, oil on canvas.

The Corcoran Gallery of Art, Washington, D.C.

The Sioux used a single stick for lacrosse, while other tribes such as the Choctaw employed one in each hand. In either case it was a rough sport.

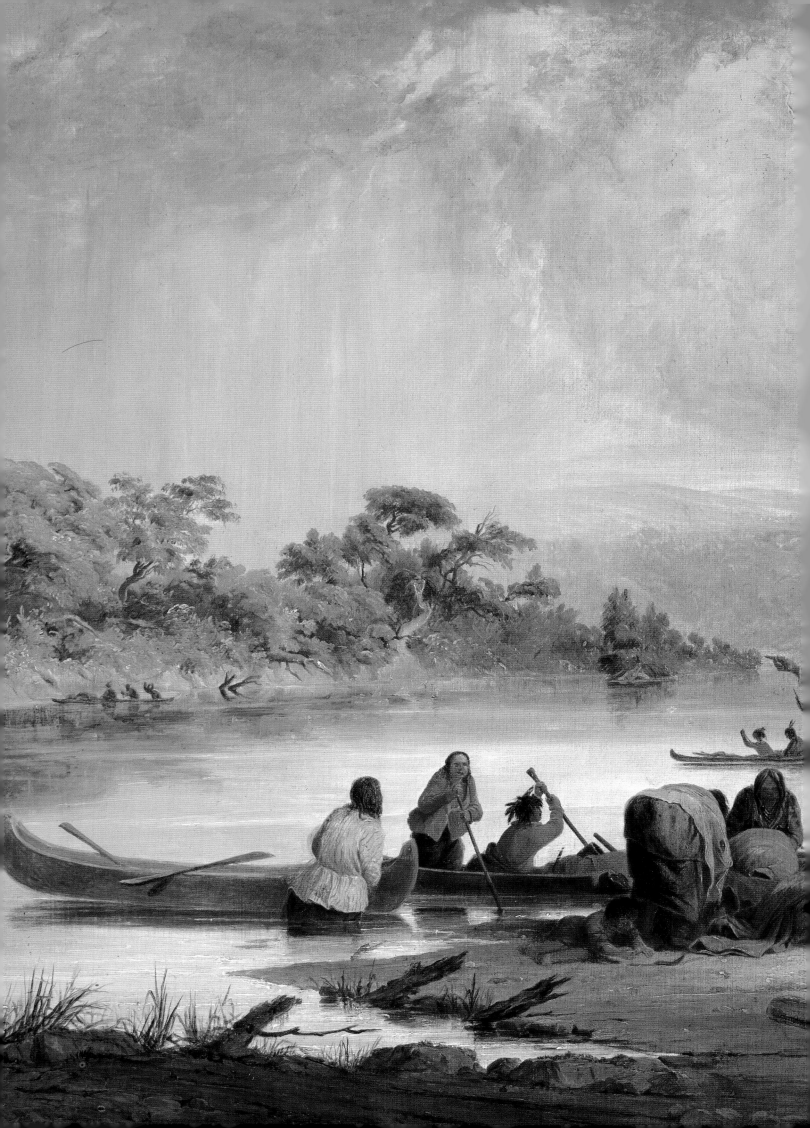

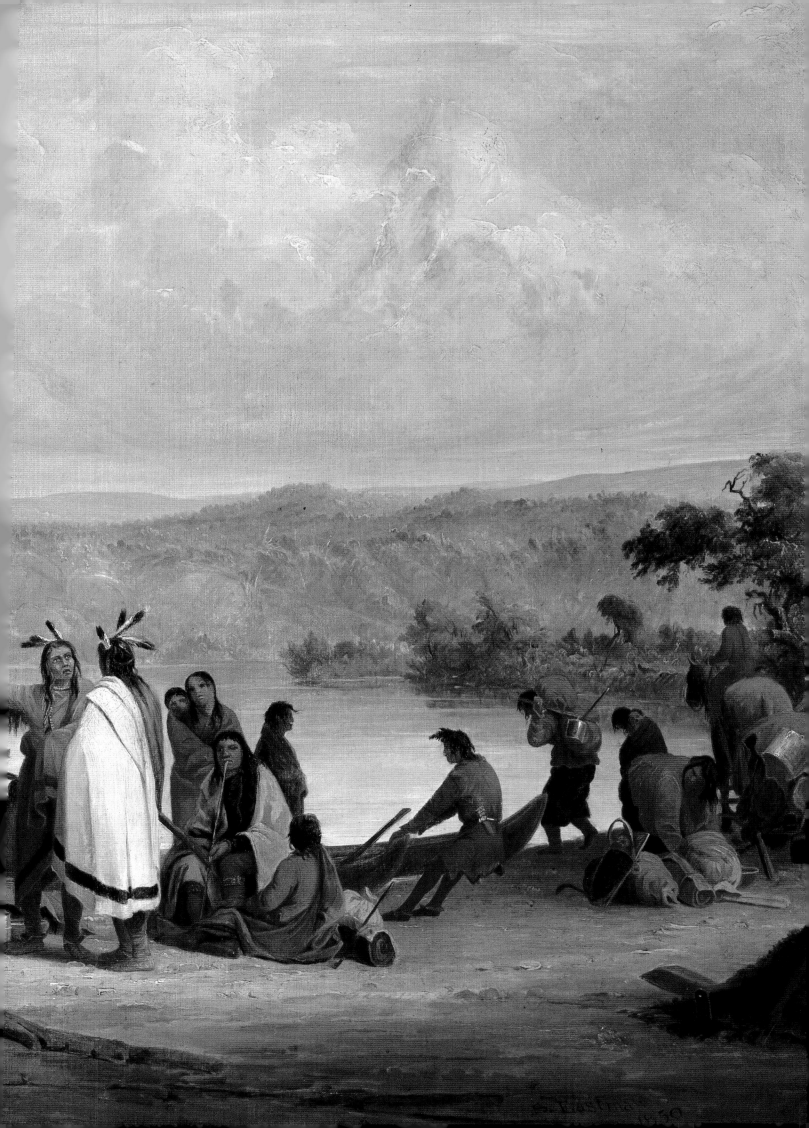

JOHN MIX STANLEY

A very different character was John Mix Stanley (1814–1872). Born the son of a western New York tavern keeper and apprenticed to a wagon maker, at age twenty Stanley removed to Detroit where he became a sign- and house painter. After studying with an itinerant artist, he made his way for some years as a portrait painter, working in Chicago, Philadelphia, New York City, and, eventually, Troy, New York, where in 1841 he learned to use a Daguerrean camera.

Armed with this and a growing interest in the profitability of "Indian paintings," Stanley arrived in December of 1842 at Fort Gibson in present-day Oklahoma. For the next three years he worked in the Oklahoma-Texas area creating a collection of some eighty paintings and the usual associated Native American artifacts. Exhibited in Cincinnati and Louisville in 1845, Stanley's Indian gallery received some critical acclaim ("His pictures are larger than those of Catlin and, we should judge, not inferior in execution," one savant declared), but not much patronage.

The gallery was closed the next year, and Stanley went west again, traveling through Kansas, New Mexico, and, finally, to California as part of the Stephen Watts Kearney expedition to San Diego. From there he traveled north to San Francisco and into Oregon where he narrowly avoided being killed in tribal fighting.

By 1849 Stanley was back in Troy and taking the expanded gallery on the road once more, ending up in Washington, D.C., where the works were temporarily hung under the auspices of the Smithsonian Institution. While awaiting the outcome of his solicitation of the museum to buy the collection, Stanley journeyed West for the last time: to spend six months as an illustrator for the Pacific Railroad Survey in what was then Washington Territory.

The Disputed Shot

JOHN MIX STANLEY

c. 1870, oil on canvas. The Corcoran Gallery of Art, Washington, D.C.
A minor disagreement, such as this one over
whose shot killed the buck, could lead to a violent
confrontation between volatile trappers and hunters.

Gambling for the Buck

JOHN MIX STANLEY

1867, oil on canvas. Stark Museum of Art, Galveston, Texas.
Gambling was an important part of Native American
life, and often a warrior would bankrupt himself
at cards, dice, or a more traditional game of chance.

On his return east, the artist married and eventually settled down in Detroit, where he continued to thrive as a popular local figure until his death. His Indian gallery remained at the Smithsonian, unpurchased but much appreciated, until 1865 when all but five canvases were destroyed in a fire. Stanley's extant Western paintings, many of which were done years after he returned from the West, are for the most part sensitive genre scenes of Native American activities with accurate renditions of costume and customs; some later works capitalize on the then popular themes of Indian massacres and white captives.

CHARLES WIMAR

Charles (Karl) Wimar (1828–1862) was born in Germany and arrived at St. Louis, Missouri, in 1843. He became familiar with the Native Americans who frequented his stepfather's tavern and those whom he met while traveling up the Mississippi with a house painter and artist to whom he was apprenticed, and he was determined to record their lives before they became, in his words, "a race clean gone."

However, the course he took was very different from that followed by most other so-called Indian painters. In 1852 he returned to Germany and enrolled at the famous Düsseldorf Academy, where his teachers (including another German-American, Emanuel Leutze) espoused a flamboyant, decorative style focusing on historic or heroic themes and favoring the bright orange, pink, and blue hues that were to be the staple of Victorian "Sunday painters" for the rest of the century.

Employing as guides engravings by Catlin and story lines from, among others, novelist James Fenimore Cooper, Wimar produced dramatic,

The Attack on an Immigrant Train

CHARLES WIMAR

1856, oil on canvas. University of Michigan Museum of Art, Ann Arbor, Michigan.

Wimar built a successful career on white fantasies, producing pictures which dramatized the violence between settlers and Native Americans.

often garishly colored images of conflict between white settlers and Native Americans. Appealing as they did to the fantasies of an eastern audience, most of whom had never ventured West, these paintings sold well. This was just what the artist desired. Upon learning that his *The Captive Charger* (1854) had brought $300, he exclaimed, "[t]his pleases me very much . . . because it is the main thing to make money quickly."

Back in St. Louis by 1856, Wimar made several further brief trips up the Missouri and Mississippi rivers on American Fur Company steamboats, gathering ethnological material (i.e., "props"), and sketching or photographing Native Americans, sometimes employing such tactics as photographing a group of Gros Ventre through a hole in a tent when they objected to being captured on film.

From 1856 until his death from tuberculosis, Wimar produced about forty-five paintings and sketches. He also did four large decorative panels for the rotunda of the St. Louis Court House, his largest public commission and a sign of the local esteem in which he was held.

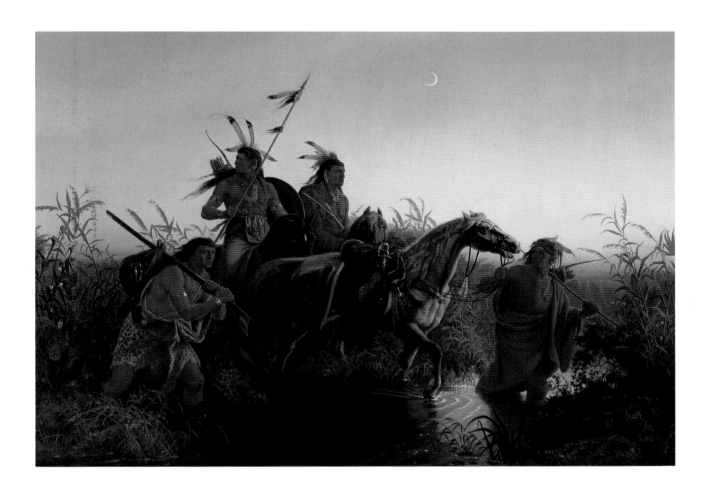

The Captive Charger

CHARLES WIMAR

1854, oil on canvas. The Saint Louis Museum of Art, St. Louis, Missouri.

Trained in the flamboyant manner of Germany's
Dusseldorf Academy, Wimar favored dramatic, decorative
themes portraying the perils of the western plains.

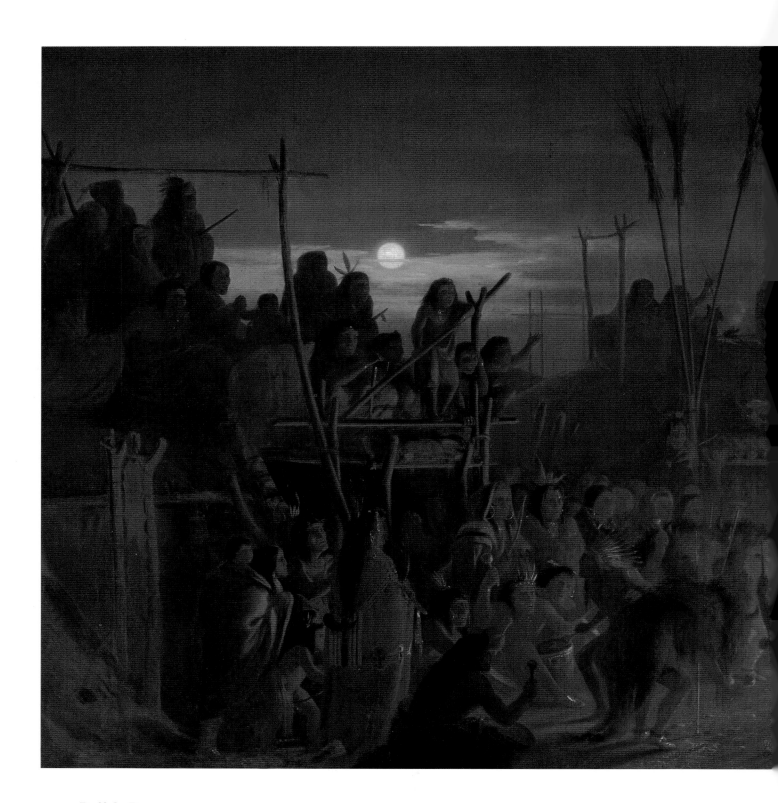

Buffalo Dance

CHARLES WIMAR

c. 1855, oil on canvas. The Saint Louis Museum of Art, St. Louis, Missouri.

Highly trained and technically skilled, Wimar was one of the
relatively few early western artists to successfully render night scenes.

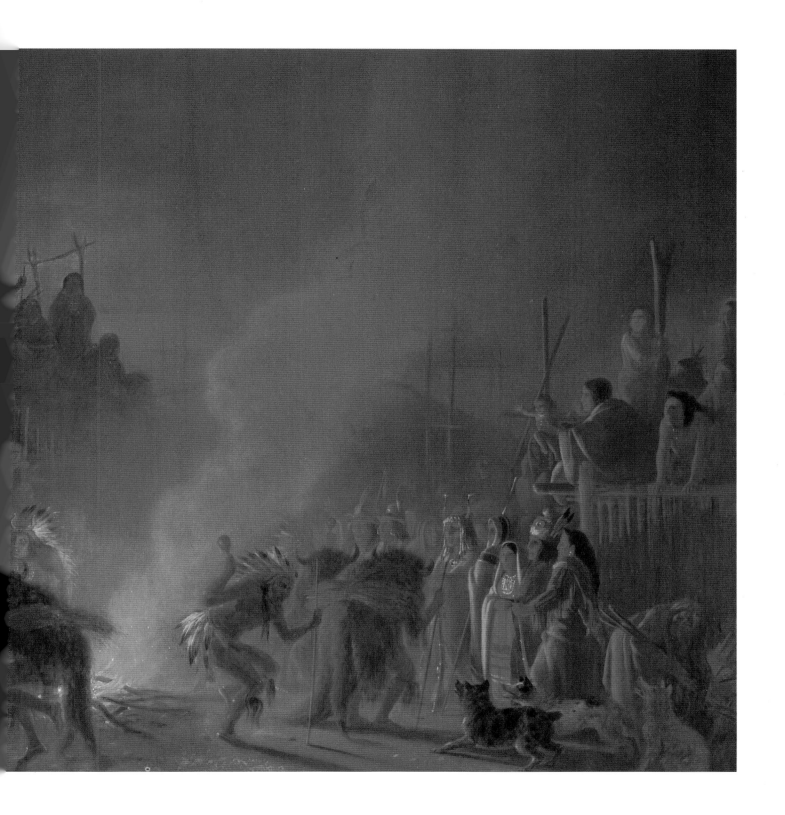

CHARLES DEAS

Another artist who had a short but spectacular career was Charles Deas (1818–1867). Born to comfortable circumstances in Philadelphia and well educated, Deas trained at the National Academy of Design. By 1839 he was already known for his genre paintings, having illustrated traditional American pastimes (The Turkey Shoot) and folk tales (The Devil and Tom Walker).

Deas was in New York City during the period Catlin's Indian Gallery was on exhibit and he had an uncle who was once governor of the Arkansas Territory, so it was, perhaps, only natural that Deas should then turn his hand to Western subjects. In 1840 he traveled throughout the Wisconsin Territory reaching Fort Crawford at Prairie du Chien on the Mississippi, where he remained for nearly a year sketching members of the Winnebago and Sauk and Fox tribes. The next year Deas was at Fort Snelling to paint a gathering

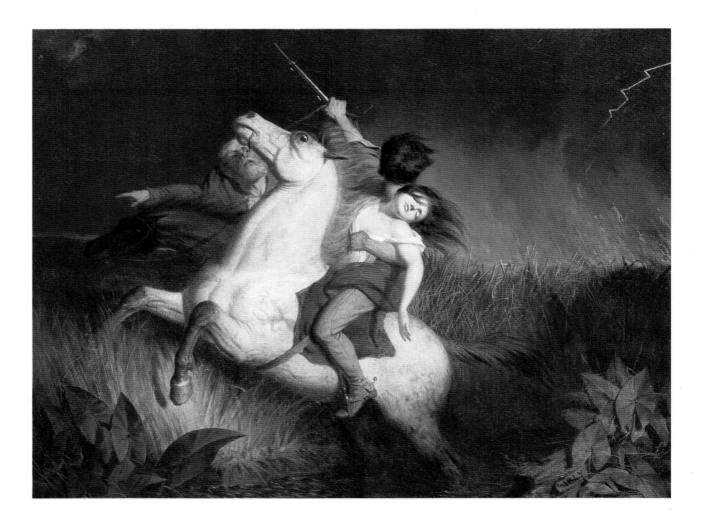

Prairie Fire

CHARLES DEAS

1847, oil on canvas. The Brooklyn Museum, Brooklyn, New York.
In this dramatic scene Deas captures the terror
of the vast fires which might sweep for days across
the grass lands, driving all before them.

A Group of Sioux

CHARLES DEAS

detail; 1845, oil on canvas. Amon Carter Museum, Fort Worth, Texas.
An elderly man smokes a pipe, the bowl of which is
made from catlinite, a soft stone highly prized and
widely traded among the western tribes.

of Sioux (just missing Seth Eastman, who returned there soon after). Some of these portraits were exhibited at the St. Louis Mechanics' Fair after the artist returned to the city in November 1841.

Deas appears to have been well established in St. Louis, exhibiting regularly and painting portraits of the local gentry. He was, moreover, described by the lithographer, John Casper Wild, as having "a large and elegant collection of Indian portraits and graphic sketches, illustrative of their manners and customs, all drawn from nature." There is evidence that Deas hoped to establish these as an Indian gallery similar to that of Catlin, but nothing ever came of the project.

In 1844 the artist ventured West once more, joining Major Clifton Wharton's summer expedition to the Pawnee on the upper Platte River. His easygoing manner and ability to speak French (a language which many tribes had acquired from the voyageurs) made him popular among both soldiers and Native Americans. However, Deas was also acquiring a reputation for eccentricity in dress and behavior that foreshadowed coming afflictions.

Deas remained in St. Louis until 1847, where he was soon recognized as a national figure. His painting *Long Jakes: The Rocky Mountain Man* created a sensation when exhibited in 1845. At this point Deas' work, while still ethnographically correct, had become peopled with idealized representations of Western types, with Native Americans (as in *The Death Struggle*) shown as violent savages bent on destruction. The serenity of earlier tribal scenes was replaced by garish colors and exaggerated gestures. Indeed, one critic described a painting (now lost) as something that

The Death Struggle

CHARLES DEAS

c. 1845–1847, oil on canvas.

The Shelburne Museum, Shelburne, Vermont.

This famous and horrendous rendition of combat is Deas' best-known work and, also, perhaps, a reflection of the mental turmoil overtaking him at the time.

The Voyageurs

CHARLES DEAS

c. 1840–1847, oil on canvas. The Rokeby Collection, Barrytown, New York.
Deas captures a domestic scene in transit—a French trapper and hunter with his Indian wife and family are bound downstream for trading at St. Louis.

would "curdle all the milk of human kindness in his breast . . . haunt him like a nightmare . . . and destroy his peace of mind forever."

Prophetic words, for Deas was himself coming unhinged. He left St. Louis for New York in 1847 and less than a year later was judged insane and committed to an institution, where he remained for the rest of his life. His last works, submitted to the National Academy of Design exhibition in 1848, were visionary quasi-religious studies largely incomprehensible to his audience, though a generous critic hoped that the artist's derangement would "shield them from the shafts of criticism."

Contemporary accounts indicate that Charles Deas produced a large body of work. However, the great majority of his sketches and paintings cannot today be located.

Fort Snelling

CHARLES DEAS

1841, oil on canvas. Peabody Museum,

Harvard University, Cambridge, Massachusetts.

Fort Snelling, in Minnesota, was one of the fortified trading posts built to further

American interests in the fur trading areas. Built to attract and protect trade,

they served also to coerce tribes reluctant to accept white hegemony.

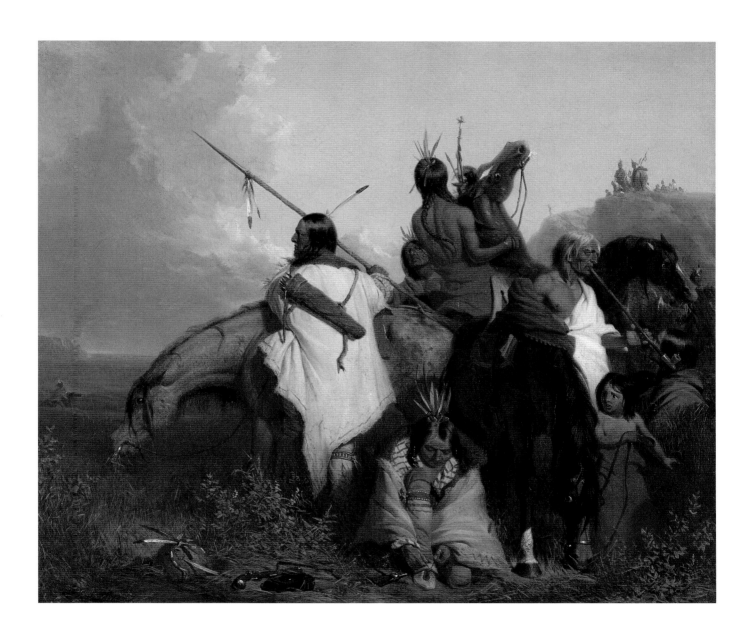

A Group of Sioux

CHARLES DEAS

1845, oil on canvas. Amon Carter Museum, Fort Worth, Texas.
In 1841 Deas visited a Sioux gathering at Fort Snelling,
in Michigan Territory. This and other paintings
captured the daily life and costume of the tribe which
was to become a bitter foe of white expansion.

WILLIAM T. RANNEY

William Tylee Ranney, (1813–1857) was born in Middletown, Connecticut, but following the death of his father, a merchant captain, he went to live with an uncle in North Carolina. By 1833 he was in New York City studying painting and drawing, and it was here that fate found him. In 1836 fighting broke out between American settlers in Texas and the Mexican army, and the artist volunteered for duty. Though he appears to have spent only a year in the Southwest the experience shaped his life and provided him with inspiration for numerous Western paintings.

Perhaps it was his contacts with the hardy immigrant bands pushing their way into what was to become (briefly) the Republic of Texas, but Ranney, unlike most of his contemporaries, was more interested in pioneers than Native Americans. The latter, when portrayed at all, usually appeared as ruthless foes trying to thwart the dream of Manifest Destiny.

Returning to New York in 1837, the artist continued his studies and a year later was exhibiting at both the National Academy of Design and the Mechanics' Institute Fair. Though listed in Manhattan directories through 1847 as a portrait painter, Ranney produced a diverse body of work that included genre scenes and historical paintings relating to the Revolutionary War and the formation of the Republic. It was not, however, until 1848 that public notice was taken of his Western paintings. In that year he exhibited one of his most poignant works, *Prairie Burial*, at the American Art Union. This bathetic representation of the burial of a pioneer child perfectly suited Victorian sentimentality. Ranney's career was assured.

He built a studio in West Hoboken, New Jersey, across the Hudson River from Manhattan, and filled it with a collection of prairie memorabilia which served both as props and inspiration. He took to heart the critic Henry Tuckerman's advice to depict "Frontier and Indian life . . . the adventures of the hunter and the emigrant . . ." as these "awaken instant attention in Europe." Ranney was not the first artist to note the enthusiasm with which European audiences greeted Western art (the more savage the better), but his unusually large, realistically rendered, and highly finished canvases found great favor with an audience accustomed to the stylistic exuberance of the Düsseldorf School.

Ranney was especially interested in trappers and his stirring canvases, such as *Halt on The Prairie* and *The Trapper's Last Shot*, portrayed a way of life which, by the time he was active in the art world, had already largely vanished. Nevertheless, the life of the trapper or hunter,

described in the writings of authors such as Cooper and Francis Parkman, held great appeal. Almost any good artistic rendition would meet with public approval.

William Ranney was at the height of his popularity when he died, another victim of tuberculosis. He left behind several unfinished paintings, at least two of which were completed by his good friend, the well-known genre painter William Sidney Mount.

Hunting
Wild Horses

WILLIAM TYLEE RANNEY
c. 1845–1855, oil on canvas. Autry Museum of Western Heritage, Los Angeles, California. Another dramatist of western life, Ranney here captures the excitement of roping one of the wild broncos which roamed the western plains and provided transportation for Native American and white alike.

FOLLOWING PAGE:

Halt On
the Prairie

WILLIAM TYLEE RANNEY
1850, oil on canvas. Archer M. Huntington Art Gallery, University of Texas at Austin. Ranney had a gift for depicting the vast western spaces and the solitude endured by travelers such as these in a land where few friends could be found.

55

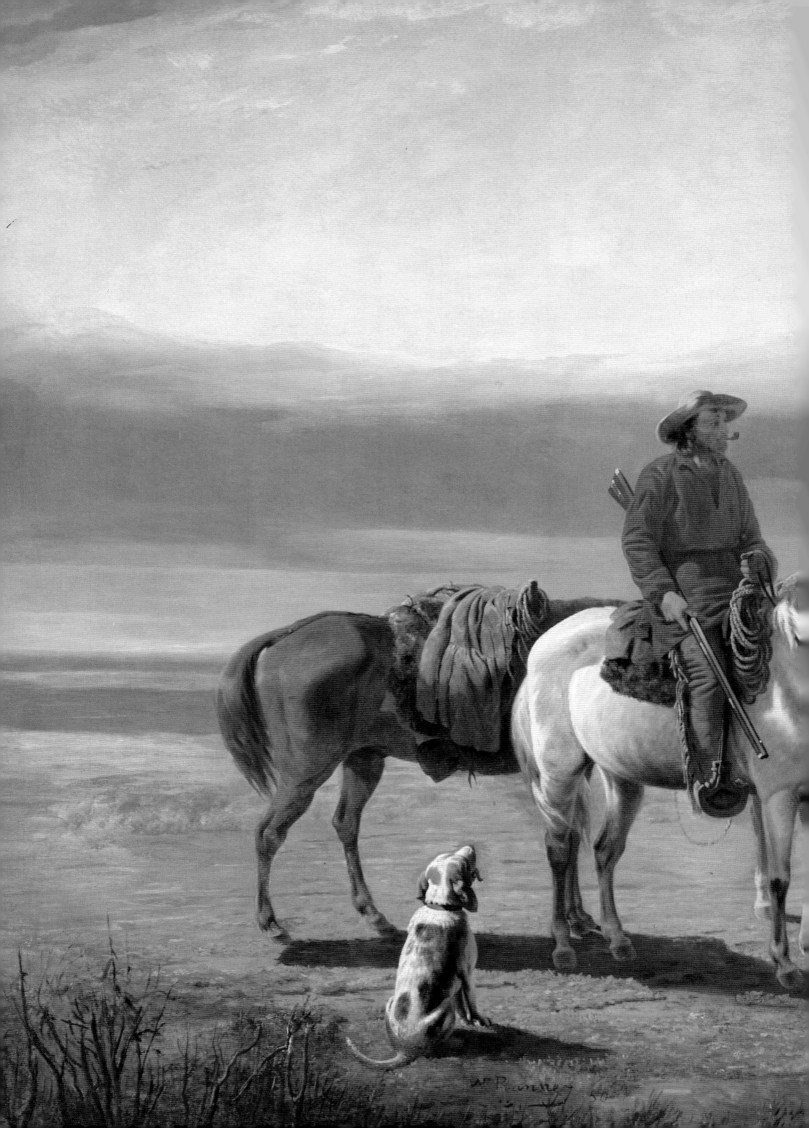

ARTHUR F. TAIT

If a Western artist could build a career on a single year in the West, perhaps one did not need to go there at all. Arthur F. Tait (1819–1905) proved that this was indeed possible. Moreover, prairie scenes were a minor part (some twenty-two paintings out of a total of over seventeen hundred) of the oeuvre of this remarkably prolific painter. He was much better known for his depictions of animals and birds and his Adirondack hunting and camping scenes.

Trappers at Fault: Looking for the Trail

ARTHUR F. TAIT

c. 1852–1860, oil on canvas. Denver Art Museum, Denver, Colorado.
Tracking game or just finding one's way across the vast prairies required great knowledge of woodcraft, as may be surmised from the concerned looks of this group of travelers.

Yet Tait must be counted among the successful painters of the West, for his Western views were circulated as lithographic print sets (*Life on the Prairie* and *American Frontier Life*) by the renowned firm of Currier & Ives. As a result, it is probable that more people saw his art and thus formed their impressions of the frontier from it than saw the work of all the other painters combined!

Born in Liverpool, England, Tait was a self-taught artist who worked for some years in his native land before migrating to the United States in 1850, supposedly after having met George Catlin in Manchester. In New York City he was befriended by William Ranney and, borrowing Western props from his large collection, Tait began a new career, as an illustrator of Western scenes. His specialty was violence: the clash between whites—pioneers or hunters—and Native American inhabitants.

The Prairie Hunter: One Rubbed Out
ARTHUR F. TAIT

c. 1852–1862, oil on canvas. Autry Museum of Western Heritage, Los Angeles, California. A highly successful western artist who never "went west," Tait specialized in dramatic renditions of the clash between whites and Native Americans. This is one of his many paintings which were reproduced as lithographs by Currier & Ives.

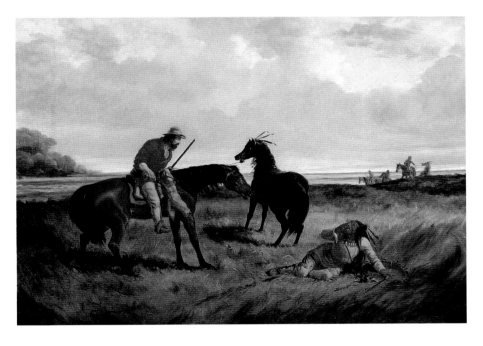

The Last War Whoop
ARTHUR F. TAIT

1855, oil on canvas. Milwaukee Art Museum, Milwaukee, Wisconsin. Probably one of the best known western paintings and subject of a popular Currier & Ives print, this picture panders to the general nineteenth-century belief that "a good Indian was a dead Indian."

Because he lacked the knowledge to accurately portray them, the latter almost always remain a distant but menacing presence, as in works such as *The Check* and *On The Warpath*.

Tait was well received in New York. By 1852 he was exhibiting at the National Academy of Design (where only one of his six paintings had a Western theme), and a year before he had sold his first illustration, T*he Prairie Hunter: One Rubbed Out*, to Nathaniel Currier. He continued to provide occasional works to Currier & Ives until 1862 when, firmly established as a painter of wildlife and sporting scenes, he retired forever from the field of Western art.

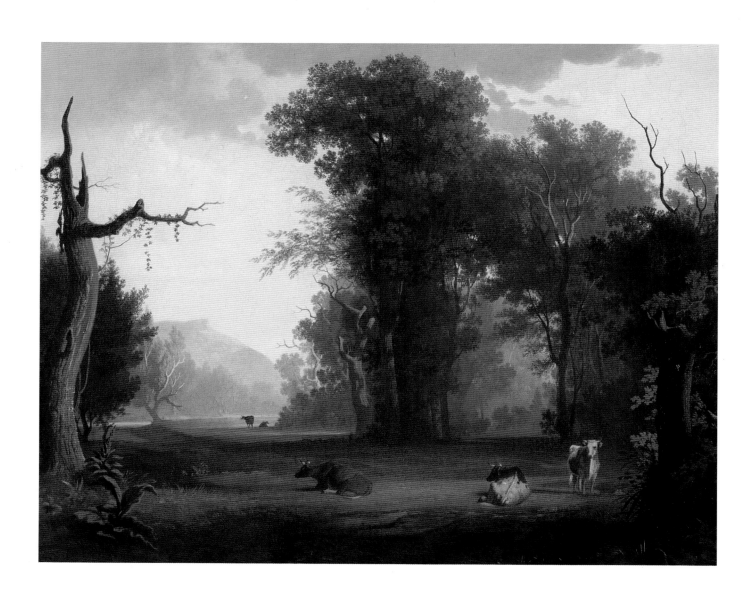

Landscape With Cattle

GEORGE CALEB BINGHAM

1846, oil on canvas. The Saint Louis Art Museum, St. Louis, Missouri.

This early work, much more in the European landscape
tradition than his famous River series, may reflect
Bingham's youth spent on a Missouri River farm.

GEORGE CALEB BINGHAM, RIVER PAINTER

ing he moved in 1838 to Philadelphia where he came under the influence of the Peale family of artists, and then to New York where he encountered the work of William Sidney Mount and where he exhibited his first river painting (now lost), *Western Boatmen Ashore*.

Bingham enjoyed modest success as a portrait painter in New York and later in Washington, D.C., and Virginia; he was, however, most highly thought of in Missouri where as early as 1839 St. Louis newspapers hailed him as the "Native

Two great rivers, the Mississippi and the Missouri, served as gateways to the West. The former had been since the early eighteenth century the link between Spanish New Orleans and French Canada as well as the eastern terminus of the fur trade. The latter, up which Lewis and Clark traveled, provided the easiest route into the prairie and mountain country. The romance of these streams with their Chippeway canoe parties, French voyageurs, trappers, and flatboatmen was captured on canvas by George Caleb Bingham (1811–1879), one of the greatest Western artists and a man whose paintings today may command as much as a million dollars at auction.

Bingham was born in Virginia, but while he was still a child his family moved west, settling in the Missouri River village of Franklin, east of what is now Kansas City. The area was, at this time, hardly settled and bands of Indians lived along or traveled up and down the broad river, while pioneer cabins and rude farms marked the coming of the white men.

Fascinated with the raw life about him, Bingham determined at an early age to be an artist. Though at first self-taught he quickly established a local reputation as a portrait and genre painter. Recognizing, however, the need for formal train-

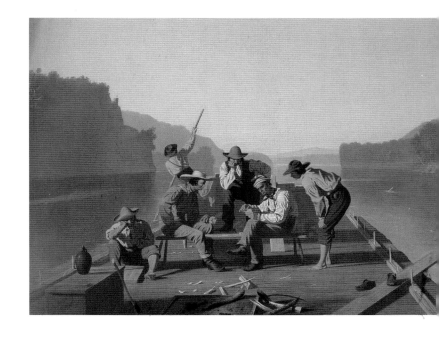

Raftsmen Playing Cards

GEORGE CALEB BINGHAM

1847, oil on canvas. The Saint Louis Art Museum, St. Louis, Missouri.
The details in this charming picture—the stoneware jug, the pair of shoes, the accurate rendition of a flatboat deck—reflect Bingham's debt to the great eastern genre painter, William Sidney Mount.

Talent" and the "Western Comet." Additionally, it was in Missouri, to which he returned in 1845, that the artist launched his career as river painter. He produced two major works that year, *Fur Traders Descending the Missouri* and *The Concealed Enemy*. The former, the first in what was to become known as his River series, was a dramatic study of voyageur types. The latter dealt with subject matter—a lurking Indian brave—to which Bingham seldom returned. His interest was not in Native Americans but in the white men, who were pushing into the Western lands, particularly the types associated with river travel. Local critics applauded the artist's new direction, and financial gain soon followed critical success.

Fur Traders Descending the Missouri was exhibit-

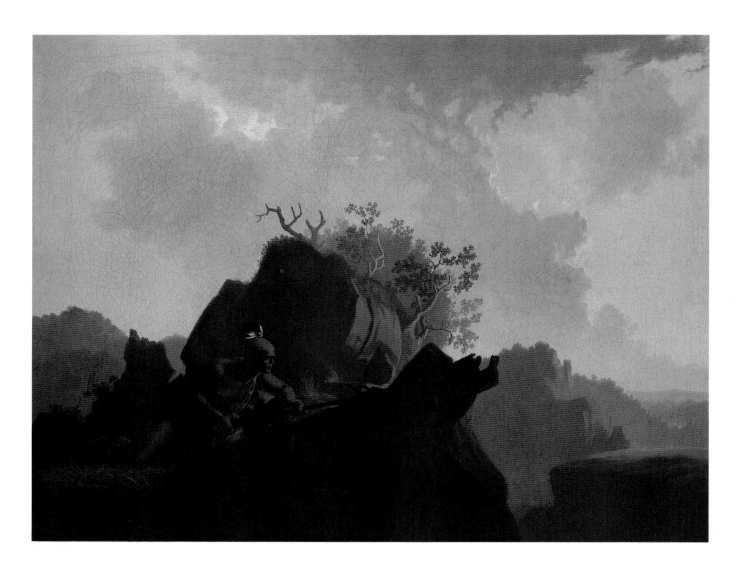

The Concealed Enemy

GEORGE CALEB BINGHAM

1845, oil on canvas. Stark Museum of Art, Galveston, Texas.

This is Bingham's only known work featuring a Native American, a reflection of the artist's greater interest in pioneer life in and around the river ports.

ed and sold through New York's Art-Union and was received with such enthusiasm that, in 1846, the artist produced two more important works in the same vein, *The Jolly Flatboatmen* and *Boatmen on the Missouri*. The former, now considered one of Bingham's finest paintings, portrays the crew of a flatboat, an ungainly craft powered by oars and poles, which was used to carry produce on the Missouri and Mississippi rivers.

By the time Bingham painted them the flatboatmen and their vessels were vanishing from these waters, replaced by the steamboat. But the romance of their work and, particularly, their crews filled with characters such as the hard-drinking Mike Fink, lived on in popular fiction. A "singular aquatic race," as author Washington

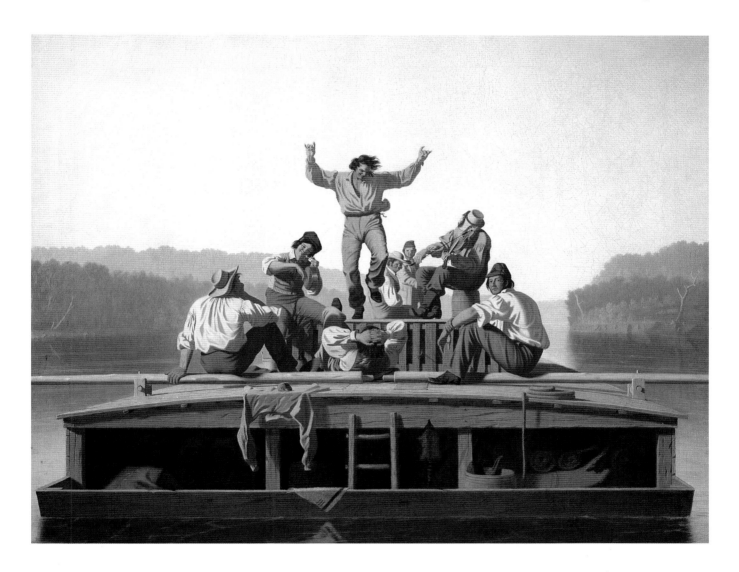

The Jolly Flatboatmen

GEORGE CALEB BINGHAM

1846, oil on canvas. The National Gallery of Art, Washington, D.C.

One of the most important paintings in Bingham's River series, this
work captures the life of the bold and exuberant men who transported
goods on the Mississippi prior to the coming of the steamboat.

Irving termed them, the boatmen were a unique group possessing, as he noted, "Habits, manners and almost a language, peculiarly their own, and strongly technical."

Bingham painted these men and their awkward, ungainly craft in every facet of their activities: Abroad on the rivers, unloading or loading cargo, at ease alongside a dock where they might while away the time, singing, dancing, or drinking. Nothing of their life escaped this painter's eye.

The last painting in Bingham's River series, *The Jolly Flatboatmen in Port*, was painted in 1857, by which time the artist had considerably expanded his horizons through the obligatory pilgrimage to Düsseldorf to sit at the feet of the German romanticists. It is doubtful that the experience greatly affected Bingham's opinion of his own work, for he declared in a letter from Germany that "I have on hand a large picture of 'Life on the Mississippi' which will not require a great deal to complete, and which promises to be far ahead of any work of that class which I have yet undertaken."

Wood Boatmen on a River

GEORGE CALEB BINGHAM

1854, oil on canvas.

Amon Carter Museum, Fort Worth, Texas.

In this dramatic night scene
Bingham pictures the leisure
pursuits of a group of boatmen
bearing wood downriver to St. Louis
to fuel the growing steamboat fleet.

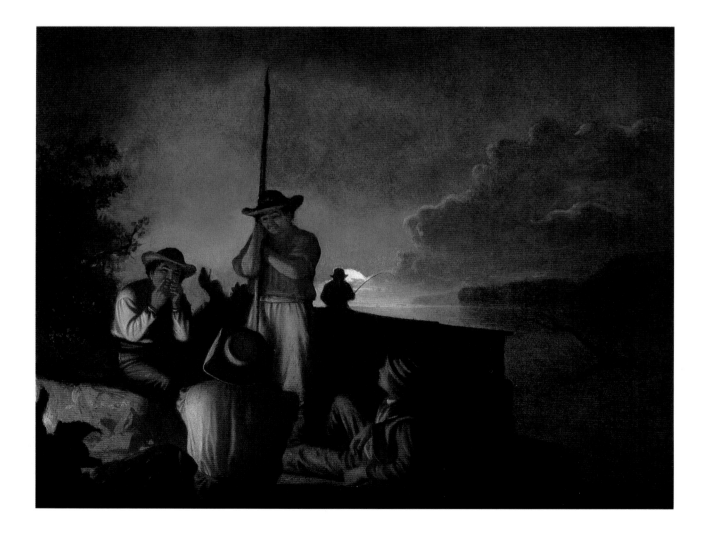

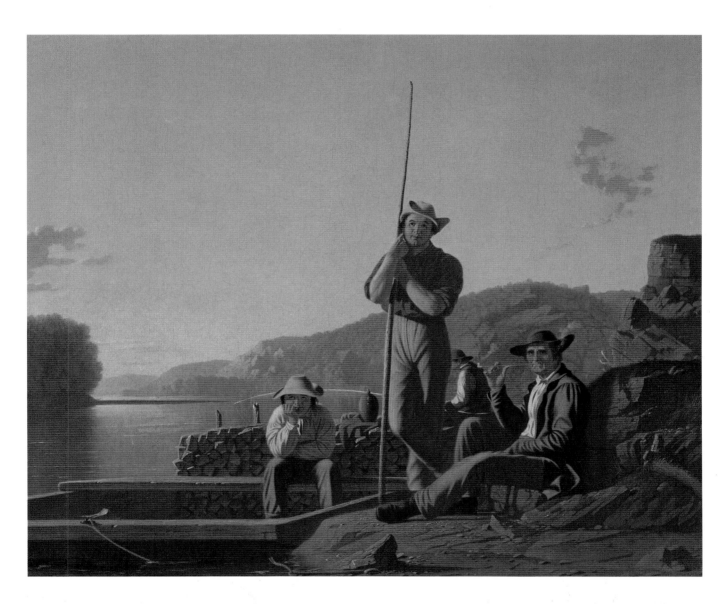

The Wood Boat
GEORGE CALEB BINGHAM

c. 1855, oil on canvas. The Saint Louis Art Museum, St. Louis, Missouri.
Flatboats like this carried the fire wood which fueled
the side wheelers which, by the 1840s, were traveling
up and down the Mississippi and Missouri rivers.

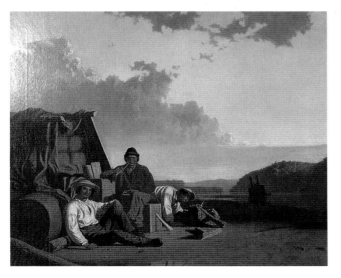

Watching the Cargo
GEORGE CALEB BINGHAM

c. 1855, oil on canvas. The State Historical Society of Missouri, Columbia, Missouri.
The flatboat men of the Mississippi and Missouri were a distinct breed
with their own ways of dress and speaking. Bingham is the only artist
to have captured the flavor of their brief reign on the great rivers.

ART AND POLITICS

In the meantime, though, the artist had gone in another direction, one no other Western artist ever assayed—he went into politics. A loyal member of the Whig party, Bingham stood for the Missouri State Assembly in 1856. His narrow defeat inspired a group of paintings, now known as the Election series, which brilliantly captured the essence of small-town Western politics.

Bingham's new work was timely. Not only was the conflict between eastern industrial areas and the agrarian West becoming more evident, but there was also a bitter dispute over expansion of slavery into the western territories. The artist's work often addressed these issues. One of the first of these paintings, *The Squatters*, pictures a family that has settled on land, privately or government owned, to which they do not have title. While the work reflects a conflict between those who would settle in the West and the large landowners (often eastern businessmen) who held title to it, Bingham's was an unflattering view of the squatters; it was his belief that it was their vote which derailed his first campaign for office. Whatever the truth of this, the artist's Election series occupied much of his time during the 1850s, and the resulting paintings, such as *The Country Politician*, *Canvassing for a Vote*, and *Stump Speaking*, proved immensely popular, several serving as the basis for widely sold engravings.

This series perhaps also reflected a change in the artist's interests, for after 1860 Bingham devoted himself more to politics than to art. After a successful second run for the state assembly, he served from 1862 until 1865 as Missouri State Treasurer and, thereafter, filled various appointive political offices until, in 1877, he accepted the position of professor of art at the University of Missouri. The popular artist-politician-professor continued to serve on the faculty until his death.

The Squatters

GEORGE CALEB BINGHAM

1857, oil on canvas. Museum of Fine Arts, Boston, Massachusetts.

As much a politician as a painter, Bingham felt that a lost bid for public office in 1856 had been due in part to the votes of people "squatting" on land they did not own. Hence, this unflattering portrayal of such itinerants.

WESTERN LANDSCAPE PAINTERS

By the 1860s conditions in the West were changing rapidly. Settlers were pouring into the region along a dozen major wagon trails, while congressional passage in 1862 of the Pacific Railroad Act promised the advent of rapid passage across the prairies. The hunters, trappers, and traders were quickly vanishing, and the Native American (though his bloody resistance would continue for decades) was slowly being pressed onto reservations.

Thanks to the work of Catlin, Miller, and their successors, Americans had become thoroughly familiar with these Western types. However, as most of these artists were illustrators, they rarely attempted to delineate the physical scenes through which their characters moved. Moreover, the most dramatic landscape, the mountains, lay largely to the west of their travels.

It remained to another generation to picture the breathtaking grandeur of the Rockies and California's Sierras. Foremost among these painters were Albert Bierstadt, Thomas Moran, and Thomas Hill. Sometimes referred to as the Rocky Mountain School, these men, like their counterparts among the Hudson River painters, created grand, highly finished canvases which owed much in composition to European prototypes, especially the work of the Düsseldorf School, emphasizing nature rather than man.

Hetch Hetchy Canyon

ALBERT BIERSTADT

detail; 1875, oil on canvas. Mount Holyoke College

Art Museum, South Hadley, Massachusetts.

The artist has carefully delineated natural elements such as grass and tree trunks. While he might alter a scene for artistic reasons, Bierstadt was always true to nature.

ALBERT BIERSTADT

Best known among the Western landscape artists is Albert Bierstadt (1830–1902). Though born near Düsseldorf, that great training ground for romantic artists, Bierstadt was initially self-taught. His family had immigrated to New Bedford, Massachusetts, when the artist was only two, and he grew up there, the son of a cooper. Though lacking the means to obtain artistic schooling, he taught himself to sketch and doggedly pursued the dream of being an artist.

In 1850 Bierstadt moved to Boston, where he advertised himself as a drawing master and worked part time running a traveling magic and slide show. By 1853 he had saved enough to return to Düsseldorf to seek instruction. There he was befriended by two American artists, Emanuel Leutze and Worthington Whittredge, who introduced him to a circle of influential painters.

Though by all accounts Bierstadt's early efforts had been undistinguished, under the tutelage of the Düsseldorf masters he rapidly became a highly accomplished landscape painter. Indeed, so striking was his artistic transformation that when he sent a painting back to New Bedford for sale, a local critic doubted that it could be from his hand.

Landscape

ALBERT BIERSTADT

undated, oil on canvas. Columbus Museum of Art, Columbus, Ohio.
This probably fictional scene combines elements
of both the Rocky Mountains and Bierstadt's beloved
Bernese Alps. For him there was little difference.

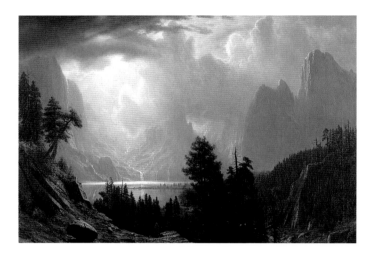

After traveling and sketching in Germany, Switzerland, and Italy, Bierstadt returned to New Bedford in the fall of 1857. His time in Europe had been well spent. Not only had he become an accomplished painter but he had made the acquaintance of many important artists and patrons and replaced the habits of a country bumpkin with the air of a gentleman—in short, a complete transformation.

Though there is little doubt that Bierstadt, struck by the similarity of the Alps to the mountains of the western United States, fully intended to apply his skills to the new landscape, he did not immediately go west. Instead he set to work painting Lake Lucerne, a monumental Swiss view which, when exhibited at the National Academy of Design in 1858, astounded the critics. Its sheer size, six by ten feet (1.8 x 3 meters), its detail, and the glowing treatment of light and air overwhelmed the viewer. Almost immediately elected to membership in the prestigious Academy, Bierstadt was hailed by one writer as that "young American artist . . . who has risen up, of a sudden amongst us, astonishing even our foremost artists with his bold strides."

In the same year the painter made his first journey to the West, accompanying a government expedition to the Rocky Mountains. A second trip, in 1863, encompassed California's Yosemite Valley (where he spent seven weeks sketching), Oregon, and Washington. Out of these rambles came a series of large, dramatic paintings which astounded the public and captivated patrons not only here but abroad. Continental critics hailed Bierstadt's work (his paintings won medals in Austria, Prussia, France, and Belgium) because he did not merely copy nature, he enhanced it. Unlike his American predecessors, the illustrators, so concerned with accurately portraying the appearance of their subjects, Bierstadt was unconcerned with geographic details—he once remarked that the Rockies looked to him "like the Bernese Alps." His landscapes were artistic compositions consisting of both fact and fiction. To achieve his ends he moved mountains, added nonexistent water courses, and created dramatic contrasts of light and shade that never existed in nature. Needless to say, his audience loved it.

Paintings like The Rocky Mountains, Yosemite Valley, and Giant Redwood Trees of California were hailed by critics and eagerly purchased by wealthy patrons. Bierstadt became very comfortable, building a thirty-five room mansion, Malkasten, (named, naturally enough, for a Düsseldorf artists' club), overlooking the Hudson River north of New York City.

Bierstadt's successful transformation of European landscape forms to American subject matter largely established the direction of the Rocky Mountain School. Though other artists were more faithful to nature, they never forgot that viewers often preferred drama over strict realism. After all, for that there was the camera, a competent new tool which Bierstadt himself was quite willing to utilize as a supplement to his sketch book.

Giant Redwood Trees of California

ALBERT BIERSTADT

1874, oil on canvas. The Berkshire Museum, Pittsfield, Massachusetts.
The sheer size of these gigantic trees astounded travelers such
as the tiny figures portrayed here in a majestic sylvan temple.

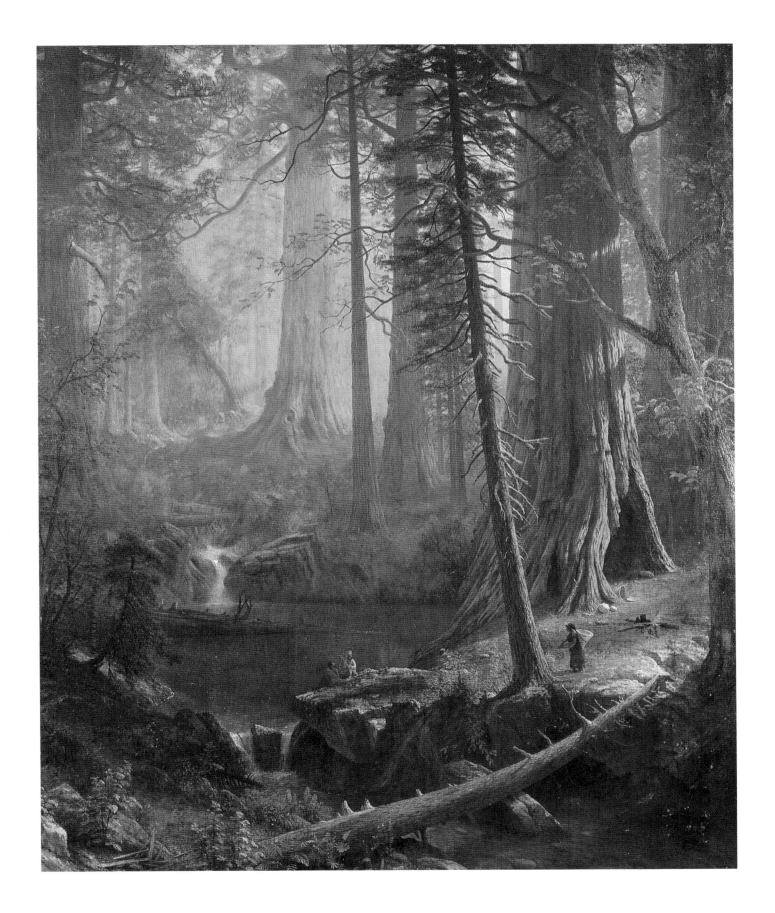

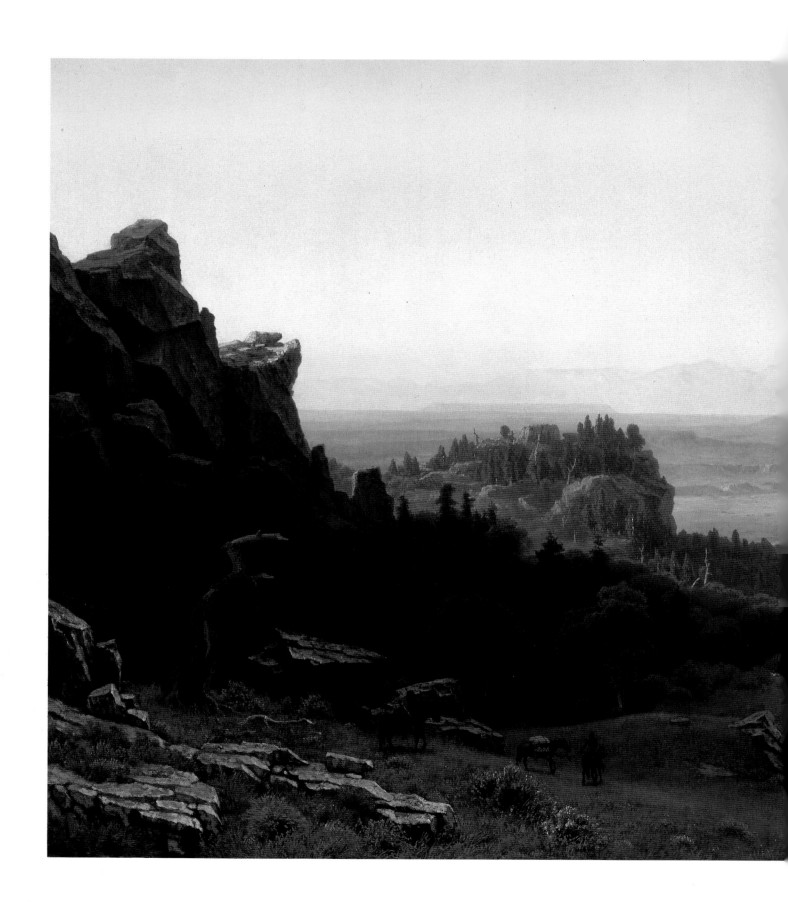

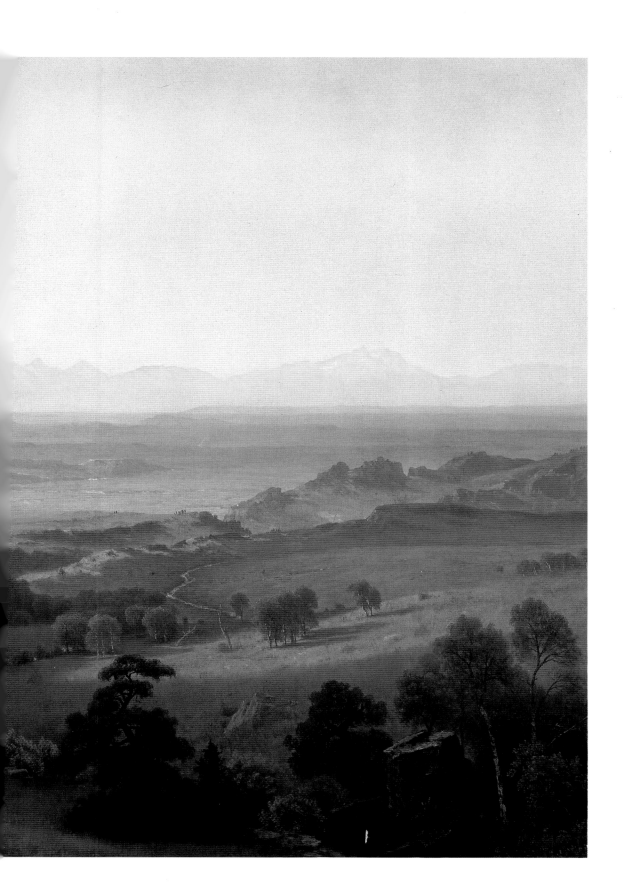

**View from
the Wind River
Mountains,
Wyoming**

Albert Bierstadt
*1860, oil on canvas.
Museum of Fine
Arts, Boston.*
Drama, rather than
accuracy in detail,
was Bierstadt's forte,
and his western
landscapes capture a
grandeur as much at
home in the Alps as in
the Rocky Mountains.

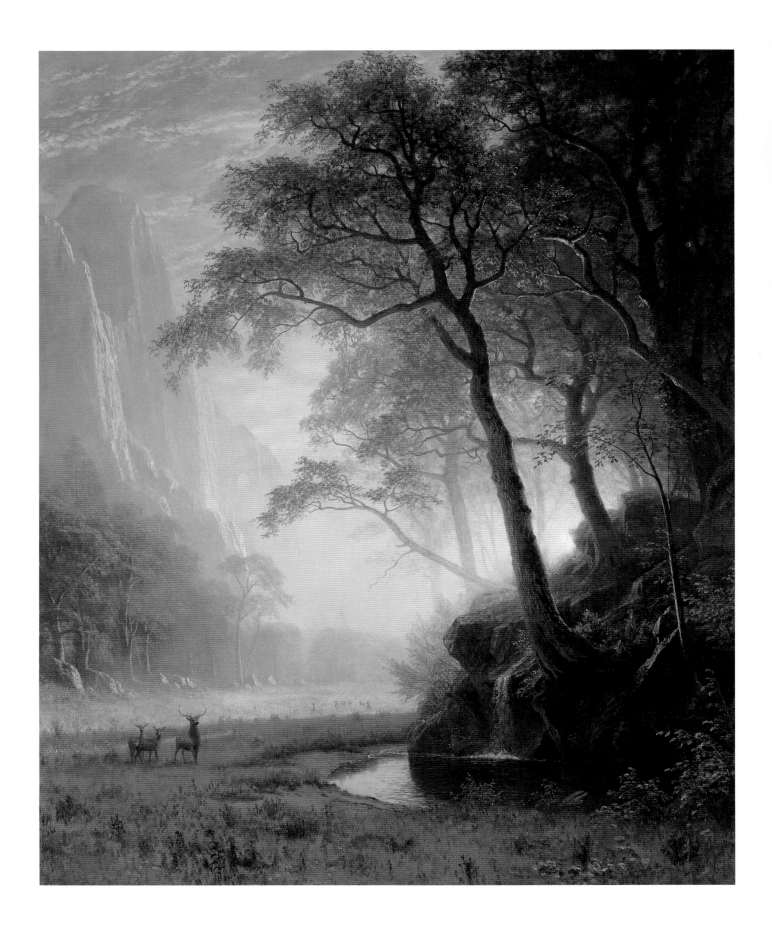

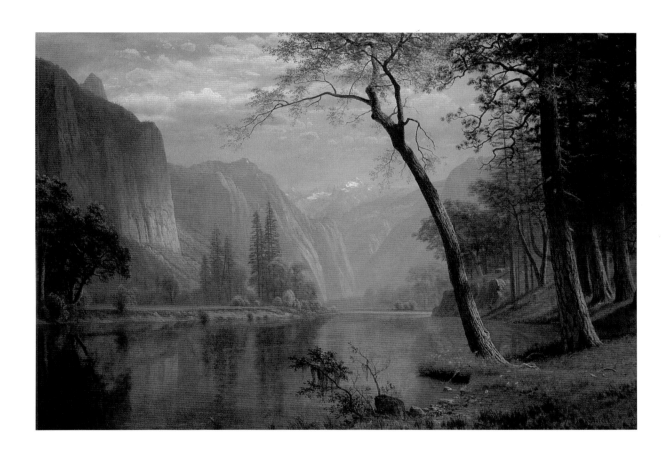

On the Merced River

ALBERT BIERSTADT

c. 1863 oil on canvas. California
Historical Society, San Francisco, California.
The European trained Bierstadt produced a
series of large, spectacular paintings of the
Yosemite area which largely made his fortune.
Highly successful, he worked late into his life.

Hetch Hetchy Canyon

ALBERT BIERSTADT

1875, oil on canvas. Mount Holyoke College
Art Museum, South Hadley, Massachusetts.
In its soft light and sensitive treatment of the elk in
the foreground, this painting differs from Bierstadt's
more typical grand and darkly brooding landscapes.

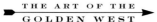
THOMAS MORAN

Thomas Moran (1837–1926), whose work rivals Bierstadt's in quality and reputation, represents yet another European influence upon American art. Born in England, Moran came to the United States at the age of seven. He was trained in Philadelphia as a wood engraver and illustrator. When he was twenty-five he returned to England for a visit and there became familiar with the work of J. M. W. Turner (1775–1851), whose extraordinary studies of light and intense color anticipated Impressionism. Moran was fascinated with the technique, but it was some years before he could apply this knowledge.

Returning to the United States, Moran continued to work as an illustrator, establishing a studio in Newark, New Jersey, and it was in this capacity that he created his first Western scenes. In 1871 *Scribner's Monthly* commissioned him to do the illustrations for an article about a recent expedition to the Yellowstone region. Based only upon some rude sketches and the author's written notations, these could hardly have been representative.

They did, however, fire Moran's imagination. He immediately determined to see and paint the West, joining in the same year an expedition to the Yellowstone organized by the United States

The Grand Canyon of the Yellowstone

THOMAS MORAN

1872, oil on canvas. National Museum

of American Art/Art Resource.

This monumental work was purchased from the artist by the United States Congress for the then-almost-unheard-of price of $10,000.

Upper Falls, Yellowstone

THOMAS MORAN

detail; 1871, watercolor on paper.

Philbrook Art Center, Tulsa, Oklahoma.

The lone figure looking out into the maelstrom might well be the artist, who visited the area in 1871.

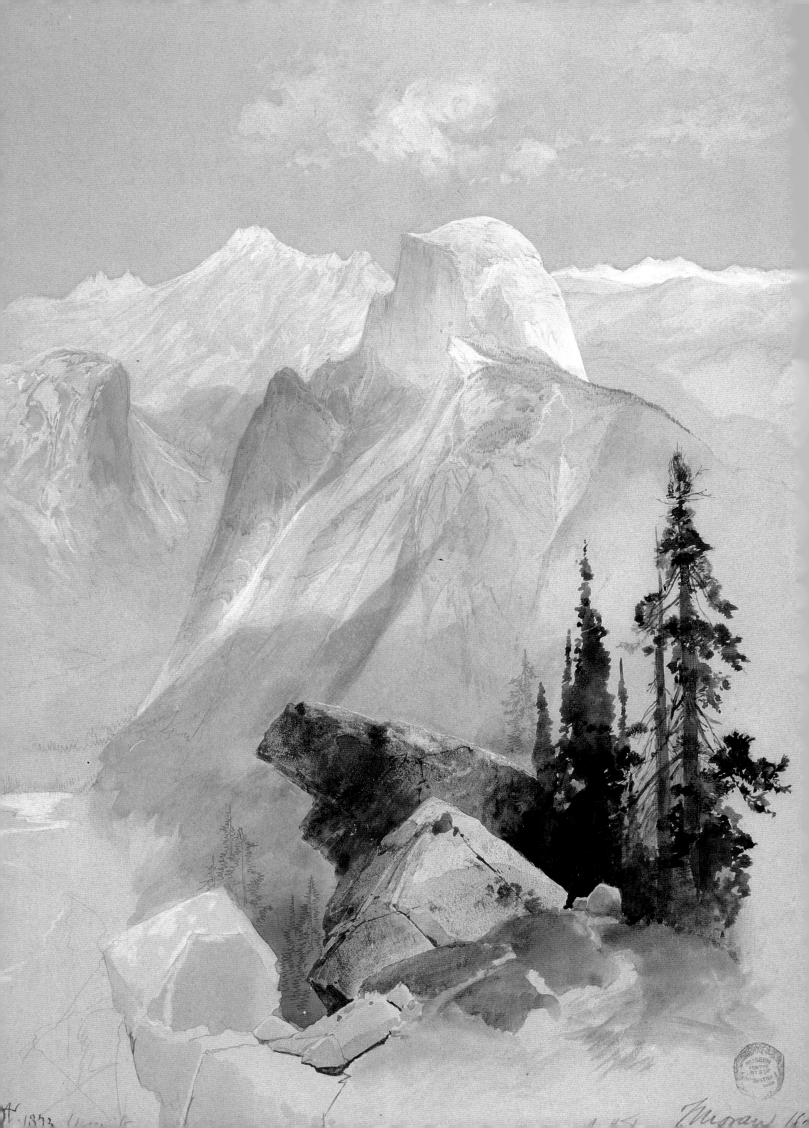

1873

Department of the Interior. He funded this venture by agreeing to supply *Scribner's* with illustrations for another article on the area and the railroad magnate Jay Cooke with watercolors to be used in promoting tourism.

An important by-product of his work accomplished at this time was the establishment by an act of Congress on March 1, 1872, of Yellowstone National Park. Once congressmen had been presented with Moran's watercolors of the wondrous Yellowstone, they immediately established the first National Park, and Moran was henceforth known to many as "T. Yellowstone Moran."

Moreover, the artist was further recognized and his artistic career assured when, in that same year, the same Congress purchased for the then unheard of sum of $10,000 his monumental oil *Grand Canyon of the Yellowstone*, now at The Smithsonian Institution in Washington, D.C.

The 1871 journey was the first of many for Thomas Moran. During the next twenty years he journeyed to the West seven more times. Among the highlights were a cruise down the Colorado River in 1873, a trip the next year to Colorado's Mount of the Holy Cross, a tour of the Grand Tetons in 1879 (the highest of which was subse-

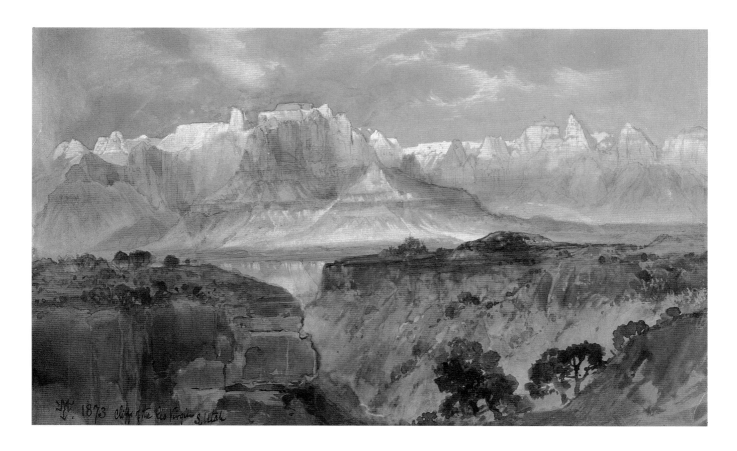

Cliffs of the Rio Virgin, South Utah

THOMAS MORAN

1873, watercolor. Cooper-Hewitt,

National Design Museum, New York.

Moran was a fine draftsman, and this sketch of the Utah back country vividly captures the shape and color of the rugged terrain.

South Dome, Yosemite

THOMAS MORAN

1873, watercolor. Cooper-Hewitt, National Design Museum, New York.

The artist was one of the first to capture the majestic form of the Half Dome, and his renditions remain the most evocative.

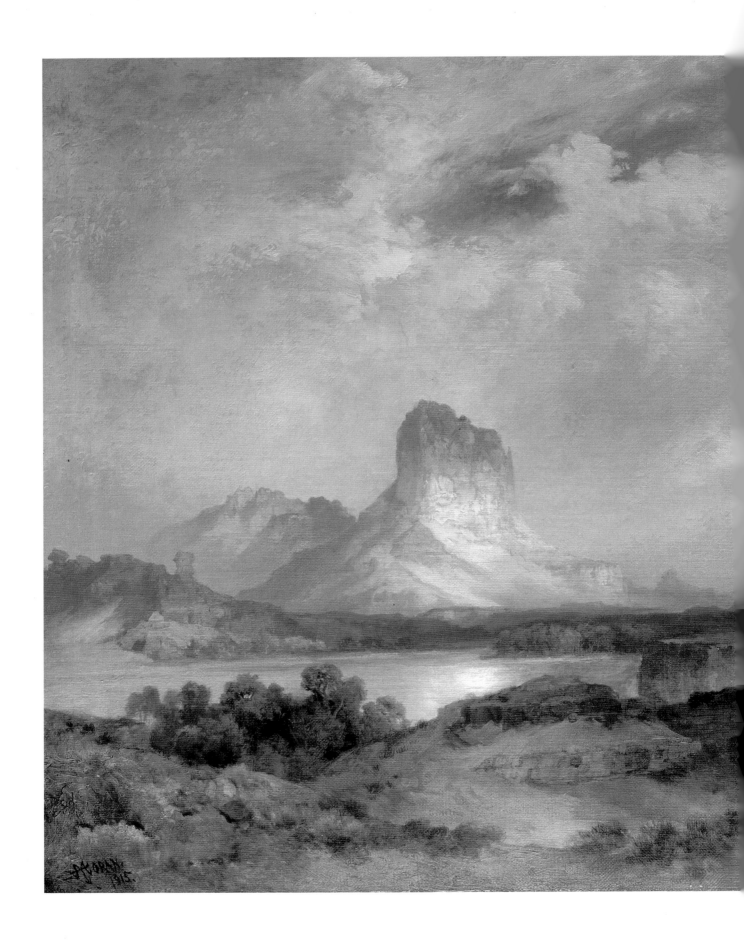

quently dubbed Mount Moran), a swing across northern Mexico in 1883, and a final grand tour of the western states in 1892.

Throughout this period and, in fact, until his death, Moran continued to work, producing a large number of oils and watercolors that extolled the virtues of the area he loved so well. However, his fondness for the Western landscape did not prevent him from altering it to suit artistic convenience. Like Bierstadt, Moran's studio technique involved balancing on his canvas elements drawn from his sketches and from memory and rearranging them within his own scheme of form and color.

Green River, Wyoming

THOMAS MORAN

c. 1879, watercolor on paper. The Nelson-Atkins Museum of Art, Kansas City, Missouri.

Moran's renderings of the great western ranges often served as illustrations for popular magazines like *Scribner's Monthly*.

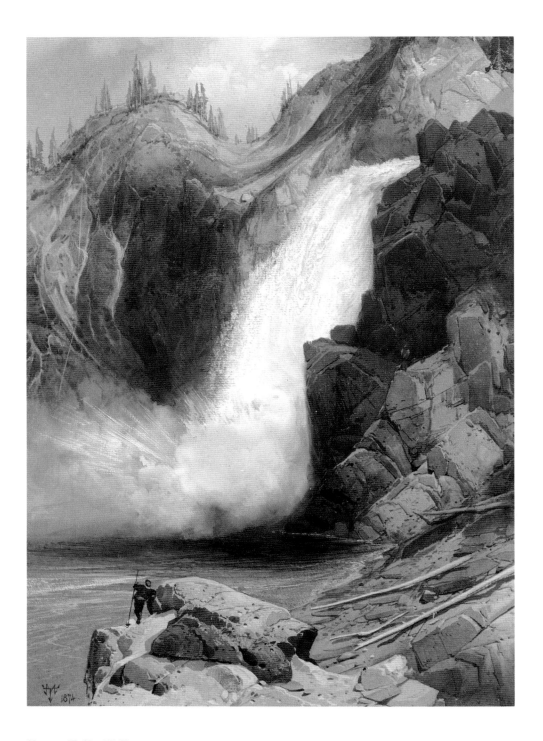

Upper Falls, Yellowstone

THOMAS MORAN

1871, watercolor on paper.

Philbrook Art Center, Tulsa, Oklahoma.

Moran's paintings were the earliest comprehensive depiction of what is now Yellowstone Park, and they led in 1872 to Congressional designation of the first American national park.

The Grand Canyon of the Yellowstone

THOMAS MORAN

detail; 1872, oil on canvas. National Museum of American Art/Art Resource.

The artist was a master at capturing the semi-arid rocky landscape of the California Sierra where, as here, water often occupied only a tiny part of the natural panorama.

THOMAS HILL

The third dominant member of the Rocky Mountain artists, Thomas Hill (1829–1908) was the only one to actually live in the West. Born in Birmingham, England, Hill was brought to the United States in 1844. The family settled in Taunton, Massachusetts, where he was apprenticed to a coach painter at an early age, and worked at the trade until moving to Boston in 1847.

Hill married there and continued his employment as a carriage painter after the family moved to Philadelphia in 1853. However, he also studied at the Pennsylvania Academy of Fine Arts and further prepared himself for an artistic career through sketching sojourns in New Hampshire's White Mountains in the company of Bierstadt and such well known eastern artists as Jasper Cropsey and John F. Kensett.

Hill had often dreamed of going West, and in 1861 he settled his family in San Francisco, working there as a portrait and scenic painter until 1867. Though the rough-hewn city was hardly a center for the arts, Hill was able to establish a reputation in San Francisco, where one critic remarked that he "caught more happily than others the peculiarly delicate purple and lilac tints of our scenery, and the tender atmospheric effects which enhance its beauty."

Like Bierstadt and Moran he employed a large format (six by ten feet [1.8 x 3 meters] was preferred), and one of his earlier works, *View of the Yosemite Valley in California*, created a sensation when shown in 1866 at New York's National Academy of Design. In the same year Hill traveled to France, where he exhibited to favorable reviews at the Paris Exposition. Upon his return in 1867 he settled in Boston. There patrons of the

Scene of Yosemite: Bridal Veil Falls

THOMAS HILL

undated, oil on canvas. California Historical Society, San Francisco, California.

No western landscape artist loved the landscape with the fervor of Thomas Hill. This dramatic rendition of Bridal Veil Falls reflects his affinity for an area in which he spent his later years.

arts marveled at his "large pictures of wild and picturesque scenery."

Though undoubtedly successful in the east, Hill longed for California, and he returned there in 1871 to become a familiar and respected member of the art world in San Francisco. By this time a wealthy class of patrons had emerged, and one of them, Leland Stanford, bought two of the artist's monumental landscapes for a total of $11,000.

Muir Glacier, Alaska

THOMAS HILL

c. 1887–1888, oil on canvas. The Oakland Museum, Oakland, California.
This is one of a group of Alaskan paintings done by Hill on commission from the famous naturalist, John Muir.

Another local luminary, Judge Edwin B. Crocker, purchased *Grand Canyon of the Sierras, Yosemite*, which is kept in the collection of the Crocker Art Museum, Sacramento.

Hill produced a wide range of scenic views as well as, unlike his contemporaries, genre paintings (such as *Irrigating at Strawberry Farm*) which captured the daily life of Californians. These more intimate works reflect his period among the New Hampshire artists, who often used nature as a background to holidaying sportsmen and visitors. Even Hill's monumental Western scenes often have more of a human and animal presence than do the works of his artistic rivals.

Hill's reputation increased throughout the 1870s. Though he continued to make trips back

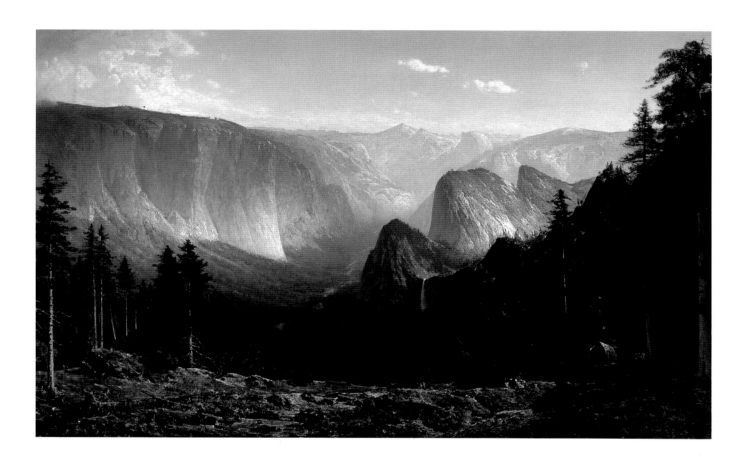

east to exhibit and to maintain gallery and patron contacts, Hill was now a Californian at heart. In 1887 he went to Alaska on commission from John Muir to paint Muir Glacier, and the next year nineteen of his paintings appeared in the naturalist's *Picturesque California*. In 1893, several of his larger oils were displayed at the Chicago World's Columbian Exposition.

Hill was continually drawn to the Yosemite Valley the locus of several of his most famous paintings. It is hardly surprising, then, that in his declining years he settled there to live in the shadows of Half Dome, Bridal Veil Falls, and all the other natural wonders which he had sketched so many times. He was there when he first suffered a stroke in 1896, and it was there he died a dozen years later.

Grand Canyon of the Sierras, Yosemite

THOMAS HILL

1871, oil on canvas. Crocker Art Museum, Sacramento, California.
Hill worked in the same monumental frame favored by his contemporary landscape artists. This painting measures 6 by 10 feet (1.83 x 3.05 meters)!

FOLLOWING PAGE:

Paper Mill Creek, Marin County

THOMAS HILL

c. 1882, oil on board. The Fine Arts
Museums of San Francisco, California.
Unlike most of his contemporaries,
Hill supplemented his landscapes
with accurate depictions of the farms,
mills, and towns of his growing state.

FREDERIC REMINGTON

Frederic Remington (1861–1909) was a romantic chronicler of the magnificent West, an artist who arrived in the region too late to witness its greatest glory but who employed his talent and imagination to capture an exciting (though not always accurate) vision of a fast-fading culture.

Unlike earlier artists depicting the West, such as Catlin, Bodmer, and Miller, Remington was not called upon to provide an ethnographically correct representation of its life and costume. By the 1880s, when he began his career, white settlers were well established in the trans-Mississippi region; and the appearance of the remaining Native Americans (as well as cowboys, mountain men, and miners) was well known. What was needed were attractive images to illustrate fictionalized Western drama—the Indian fights, saloon brawls, cattle roundups, and gold strikes that guaranteed sales for such popular periodicals as *Harper's Weekly*, *Century*, and *Scribner's Magazine*.

A Cavalryman's Breakfast on the Plains

FREDERIC S. REMINGTON

detail; 1892, oil on canvas.

Amon Carter Museum, Fort Worth, Texas.

The troops are probably boiling coffee in the large pots. It would be accompanied by hard tack and, perhaps, a bit of salt pork.

That Remington understood this well is reflected in his response to author Francis Parkman, who had asked him to illustrate a new edition of his monumental *The Oregon Trail*, a book based on the writer's Western travels in the 1840s. Remington suggested that for the sake of accuracy in comprehending Indian costume Parkman examine Karl Bodmer's art work which dated to the same period. While praising Bodmer's work, Remington stated simply, "I desire to symbolize the period of the Oregon Trail." Drama, not detail, was what he knew his audience craved.

Remington reached artistic maturity at a time when the frontier was vanishing. The Pacific coast had been settled, the Indian lands were being overrun, and the dream of striking it rich in the West was being replaced by the reality of transcontinental railways, mining syndicates, and quarter-section allotments. Yet its image persisted, and this determined artist fashioned a career from it, though he may have seemed a somewhat unlikely prospect.

THE EARLY YEARS

Born into a comfortable middle-class family in Canton, New York, he was the son of a successful journalist and politician. The family assumed that Frederic would take the same course. However, as his father was financially interested in harness racing, the young Remington grew up around horses, spending hours observing and sketching them.

Though tolerated, the youngster's interest in art was not well received by a family accustomed to more stable pursuits. At the age of fourteen he was shipped off to prep school, first in Vermont and then to the Highland Military Academy in Worcester, Massachusetts. A military career may have been considered (his father, Pierre, had been a Union officer during the Civil War), but in the fall of 1878 Remington entered Yale University as a matriculant in the School of Fine Arts.

The curriculum was then yet newly established and by some accounts the faculty was not greatly interested in the student artists. However, it is likely that Remington here received a foundation

Register Rock, Idaho

FREDERIC S. REMINGTON

1891, oil on canvas. Amon Carter Museum, Fort Worth, Texas.
This large outcrop was one of several upon which western travelers scratched their names as mementos of a hard and often final journey.

in figure drawing, which was to stand him in good stead in his future career. He certainly appears to have enjoyed his time in New Haven, doing sketches for various college publications and playing on the varsity football team. Most important, he established a variety of personal connections among the wealthy students which were to serve him well throughout his life.

The death of his father in February of 1880 led to a change in Remington's circumstances. He had not been wholly pleased with the instruction he was receiving, and the resulting financial and family concerns caused Remington to withdraw from school. Following customary practice of the times, his uncle, Lamartin Remington of Albany, New York, was appointed his guardian. Frederic moved to the state capital where, through his uncle's influence, he held several government clerkships. None of them appear to have interested him greatly, and he spent most of his time sketching his fellow drudges at work or play. Remington was clearly not cut out for a political career. Moreover, the previous year he had met a

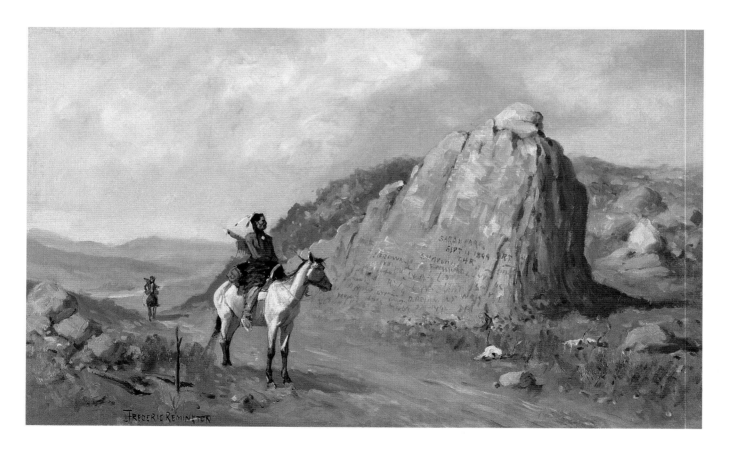

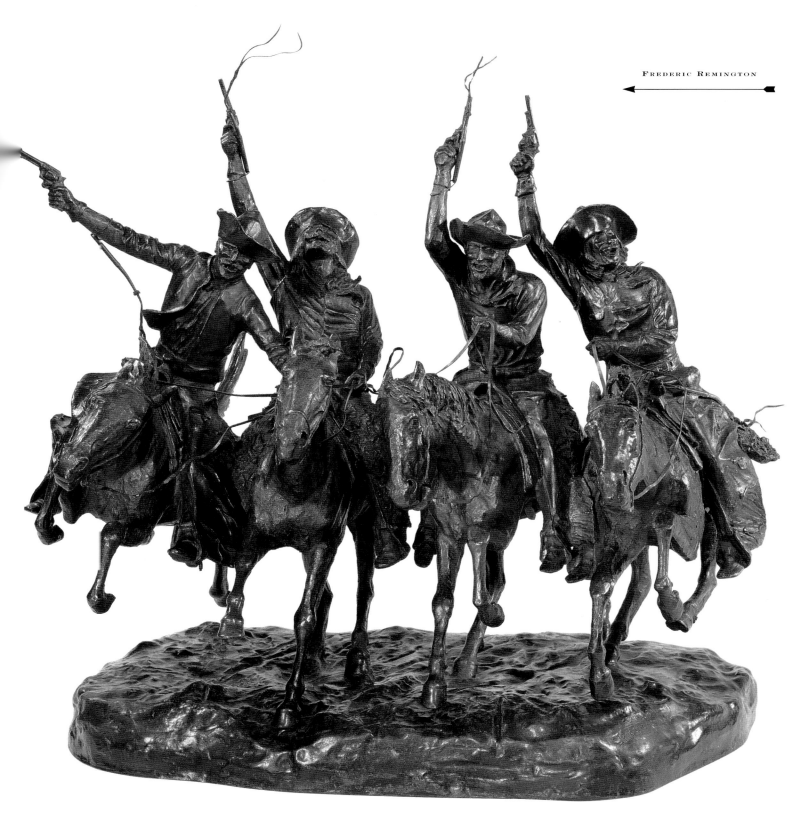

young woman named Eva Caten, whom he fancied, and he sought her hand in marriage. Her family's rejection of his suit, apparently based on the dubious nature of his prospects, spurred him to make a move. He decided to go West.

This trip to the Dakotas and Montana consumed only a few months, but it proved of lasting importance to Remington's aspirations. Returning with numerous sketches of Plains life he presented one of these to the editor of the prestigious *Harper's Weekly*. It was accepted and, reworked by a staff

Coming Through the Rye

FREDERIC S. REMINGTON

1902, bronze, cast c. 1916.

Amon Carter Museum, Fort Worth, Texas.

One of the artist's most famous pieces,

this depiction of cowboys heading

into town after a hard day on the range

has been reproduced many times.

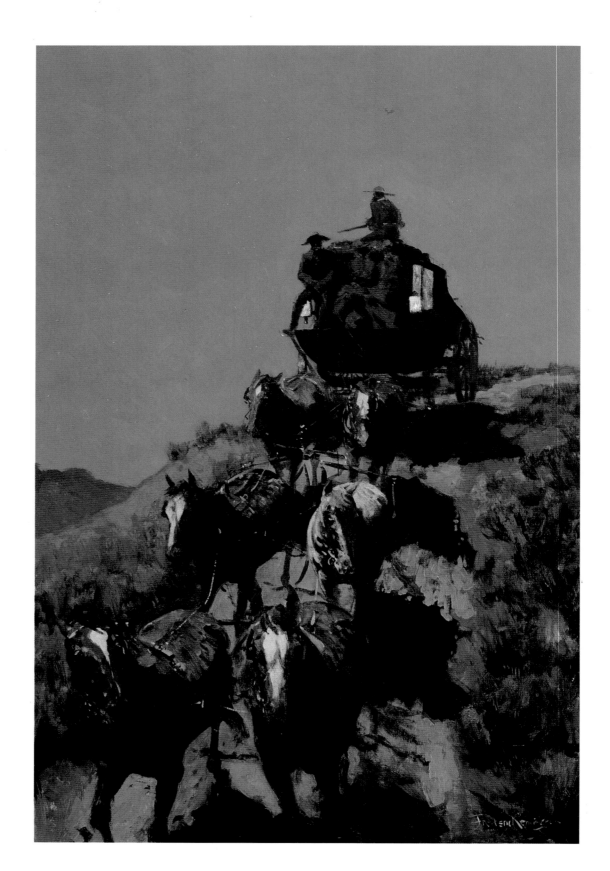

**The Old
Stage Coach
of the Plains**

FREDERIC S. REMINGTON

*1901, oil on canvas.
Amon Carter Museum,
Fort Worth, Texas.*
Remington's night
scenes, done late in
his career, are among
his finest works. Here
the stage coach glows
with an inner light
as the silent guard
and driver shepherd
it through the night.

artist but credited in part to Remington, it launched his career—a career, incidentally, which had already been given direction by a chance meeting on the western Plains. Overtaken by night he had sought the campfire of an elderly teamster who lamented the passing of the way of life he had known. In an article in *Collier's Magazine* in 1905 Remington recounted the old timer's words and noted that even then: "I knew the wild riders and the vacant land were about to vanish forever . . . Without knowing exactly how to do it, I began to try to record some facts around me."

The Fall of the Cowboy

FREDERIC S. REMINGTON

1895, oil on canvas.

Amon Carter Museum, Fort Worth, Texas.

The coming of the barbed wire,
fencing off the open plains, and ending
the great cattle drives sounded the
death knell for the traditional cow poke.

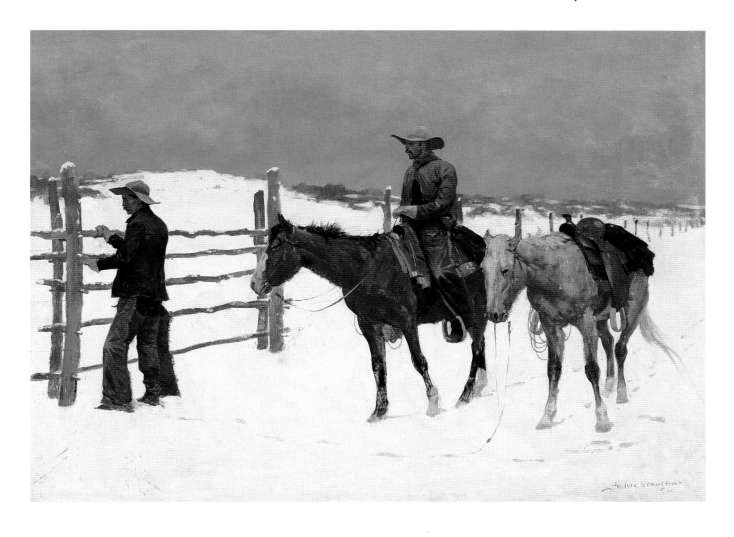

SUCCESS IN THE WEST

This "recording" was to go on for the remainder of his life. However, all was not smooth sailing, at least not at first. In October of 1882, at age twenty-one, Remington obtained control of his inheritance. Influenced by a friend from Yale he decided to go into sheep ranching in Kansas. This proved not to his liking, and in little over a year he sold his spread. The same year Remington at last married his sweetheart, Eva. They settled in Kansas City, a booming cattle center, where Remington

A Cavalryman's Breakfast on the Plains

FREDERIC S. REMINGTON

1892, oil on canvas. Amon Carter Museum, Fort Worth, Texas.
In the struggle for the western plains, Remington's sympathy lay with the soldiers who protected the settlers, especially the cavalry with whom he had ridden.

bought into a local saloon. Though he appears to have taken advantage of the facilities, the artist made nothing on his investment; finding themselves economically pressed, the couple withdrew back east where, by 1886, they were settled in Brooklyn, New York. This marked the end of Remington's residence in the West. Though he visited the area often, he never again lived there.

Remington briefly honed his skills at Manhattan's famous Art Students League (his last formal training), but by late spring he was off to the West again, sketching in Arizona, New Mexico, and Colorado as well as northern Mexico. The work he brought back excited publishers. Before the year was out it appeared in *Outing* (whose editor was another Yale crony) and *St. Nicholas* magazine as well as *Harper's Weekly*.

The painter's career began to take off. Though illustration was well thought of in America's egal-

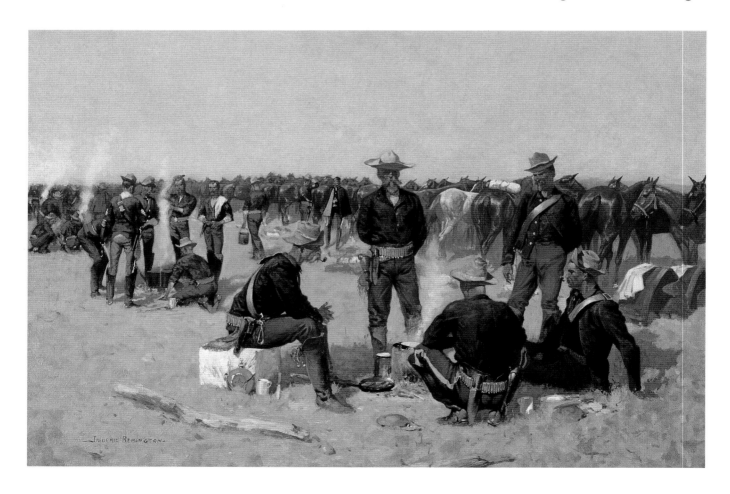

itariar society (unlike in Europe, where it was looked down upon by "serious" artists), Remington sought academic fame as well. In 1887 he exhibited for the first time at the National Academy of Design and the American Water Color Society. *His Return of a Blackfoot War Party*, exhibited at the former venue a year later, was hailed by the critics.

Perhaps more important, Teddy Roosevelt chose Remington, also in 1888, to illustrate a series of articles on Western ranching and hunting, which he was writing for *The Century Magazine*. Out of this collaboration grew a lasting friendship and more opportunities for the artist.

By the end of the 1880s Remington had more assignments than he could fill. He expanded his skills from pen and ink to watercolors and oils and supplemented his sketch book with a camera. Moreover, he became an author in his own right, writing

and illustrating articles about his wanderings among the Apache, Cheyenne, Kiowa, Comanche, Wichita, Navajo, and Pueblo. He also collected a large quantity of "props"—Native American clothing, art, and weapons, which he employed to assure accuracy in his illustrations and which he stored first in Brooklyn and, after 1890, in a home and studio in New Rochelle, New York.

Remington was fascinated by the Native Americans but he was not greatly interested in their fate. The American military, with whom he

In a Stiff Current

FREDERIC S. REMINGTON

1892, oil on canvas. Sid Richardson Collection of Western Art, Fort Worth, Texas.

This monochromatic representation of voyagers pulling through rapids is atypical in subject matter and was probably done as an illustration for one of the outdoor magazines for which Remington worked.

had ridden on punitive expeditions against Sioux and Apache, commanded his allegiance as did the cowboy, the buffalo skinner, the trapper, and the various other practitioners of arcane crafts which were rapidly disappearing with the gentrification of the Great Plains. These men he understood, and depicted in his work.

By 1890 Remington, only three years into his career, was nationally known. His work, some four hundred illustrations in all, had appeared in nearly a dozen popular periodicals as well as several books. He had also received in that year an honorary B.F.A. from Yale, thus completing his interrupted college education. In addition, in 1889 he had been awarded a silver medal for *A Lull in the Fight*, an oil exhibited at the Paris Universal Exposition, and he continued to show with success at the National Academy of Design, which, in 1891, elected him to an associate membership.

His bold colors and harsh vistas (so unlike the romanticized Western landscapes of Bierstadt and Moran) served to capture the essence of an unforgiving land but one in which the human figure, however beset, was central. Remington was first and foremost a narrative painter, and as he noted in *Men With Bark On*, "My art requires me to go down . . . the road where the human beings are . . . in the landscape which to me is overpowered by their presence."

The Bronco Buster

Throughout the 1890s Remington continued his Western field trips, often three or four in a single year, ranging from Canada south through the Plains states to Mexico. But the sojourns proved progressively less satisfying. The land continued to change rapidly, as it was built up and "easternized." He protested to his wife in a letter written in 1900, "It is all brick buildings, derby hats and blue overhauls, it spoils my early illusions, and they are my capital."

Remington, however, was far too wise to get caught in a cultural time warp. He, too, had begun to change. In 1895 he had made the acquaintance of the sculptor, Frederic W. Ruckstull, and encouraged by him had begun to consider the plastic form. Presented by Ruckstull with tools and clay, Remington started to work in the new medium. He made remarkable progress.

In October of that same year he copyrighted his first bronze, *The Bronco Buster*. The critics raved; one declared, in true Western parlance that the artist had "struck his gait." In 1896 came his second and much more complex sculpture, *The Wounded Bunkie*. Others followed: *The Wicked Pony* (1898), *The Cheyenne* (1901), *Coming Through The Rye* (1902), and *The Mountain Man* (1903), all realistic and highly animated figures. Today Remington is, among many, better known as a sculptor than as a painter.

Remington's paintings also underwent a transformation. By the mid 1890s a group of American artists working in the Impressionist manner had begun to form in Boston and New York. Remington found that, with the passage of time and the disappearance of the West he had known, this style suited him better. He left realistic illustration to Charles Russell and began to study light and color.

The landscape, which he had previously viewed only as background, came to occupy his attention, and hard outlines were gradually replaced

The Mountain Man

FREDERIC S. REMINGTON

cast 1903, bronze. Amon Carter Museum, Fort Worth, Texas.
Though it is doubtful that he ever saw a true mountain man (all were dead or retired by the time Remington went West), the artist captured their wild, independent spirit in this moving work.

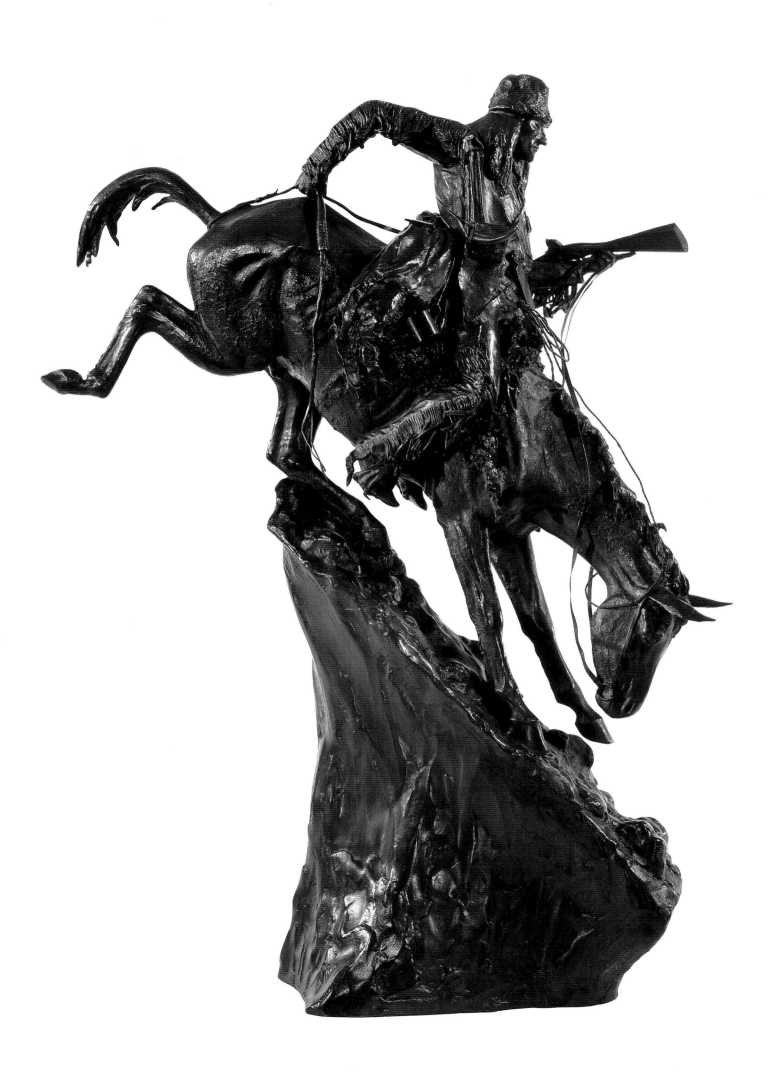

Trooper of the Plains

FREDERIC S. REMINGTON

cast 1909, bronze. Amon Carter
Museum, Fort Worth, Texas.
Remington knew the cavalrymen
well, collected their gear, and wrote
of their exploits. His appreciation
of the type is reflected in this work.

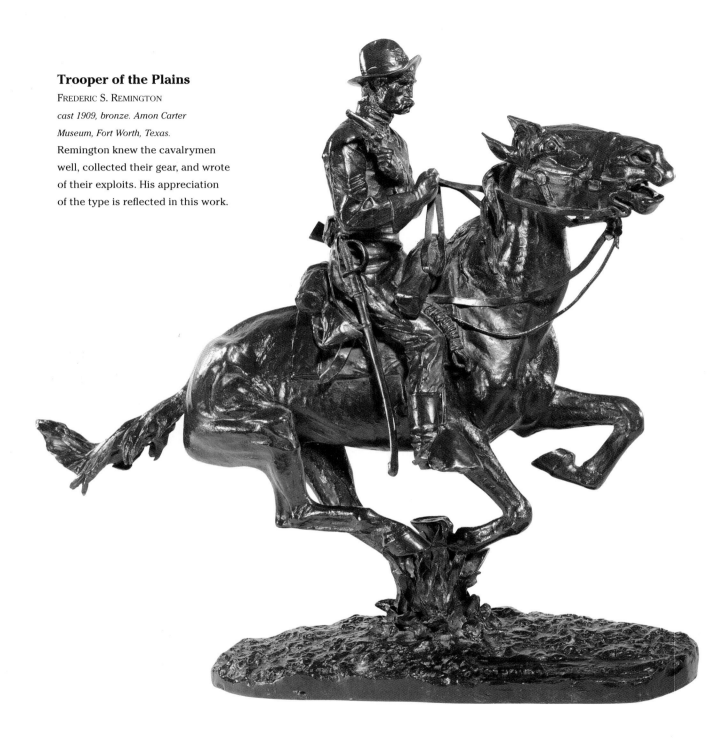

by shimmering colors and strong brushstrokes. When, in 1908, after completing Cavalry Charge On The Southern Plains, he noted in his diary that he had "always wanted to be able to paint running horses so you could feel the details instead of seeing them," the transformation from illustrator to fine artist was complete. During the remaining years of his life Remington devoted himself to impressionistic studies of western scenes, partic-

ularly nocturnal. He was intrigued by moonlight and shadows, and half of his later works were night views.

A popular and lucrative success in his waning years, Remington could well declare, as he did in a 1909 letter to a friend, "I am no longer an illustrator." Unfortunately, he had little time to glory in his new status, dying of appendicitis at the age of forty-eight.

Apache Medicine Song

FREDERIC S. REMINGTON

1908, oil on canvas. Sid Richardson Collection of Western Art, Fort Worth, Texas.

Though he normally had little sympathy for Native Americans,
Remington could portray them sensitively, as in this campfire scene.

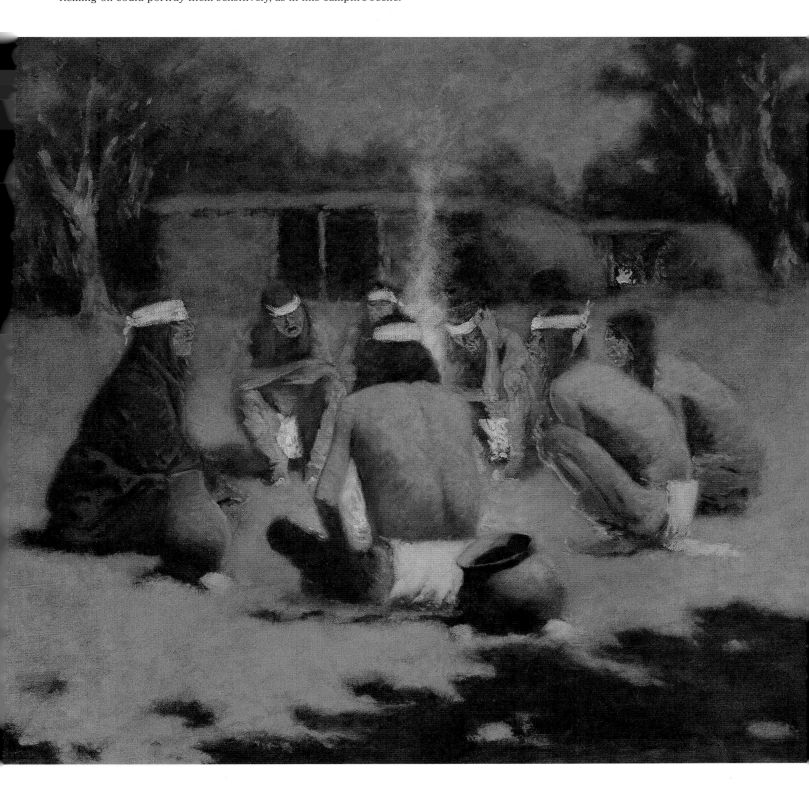

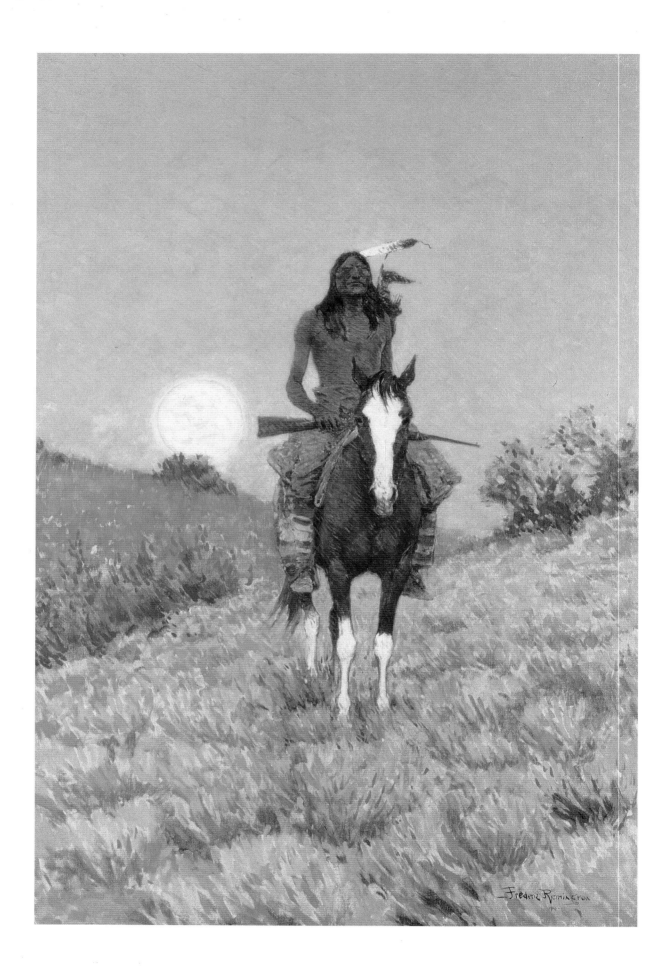

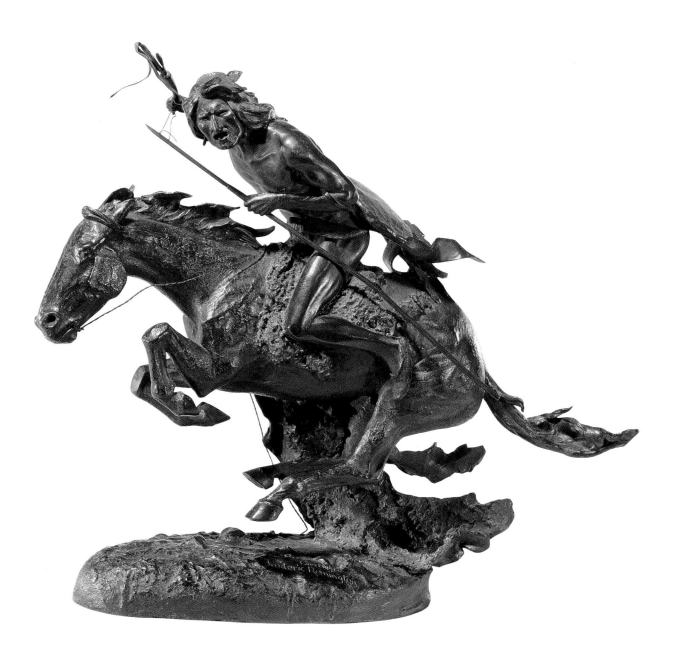

The Cheyenne

FREDERIC S. REMINGTON

cast 1907, bronze. Amon Carter Museum, Fort Worth, Texas.

With all four feet off the ground the brave's steed almost
flies off the framework of this dramatic composition.

The Outlier

FREDERIC S. REMINGTON

1909, oil on canvas, The Brooklyn Museum, Brooklyn, New York.

Remington's best work, as here, assumed a semi-abstract quality, with
tone and color more than the figure carrying the essence of the painting.

FOLLOWING PAGE:

His First Lesson

FREDERIC S. REMINGTON

1903, oil on canvas.

Amon Carter Museum, Fort Worth, Texas.

Breaking a wild horse to saddle
was never easy, and often
dangerous. Here the animal's right
back hoof has been tied to limit
its mobility and kicking power.

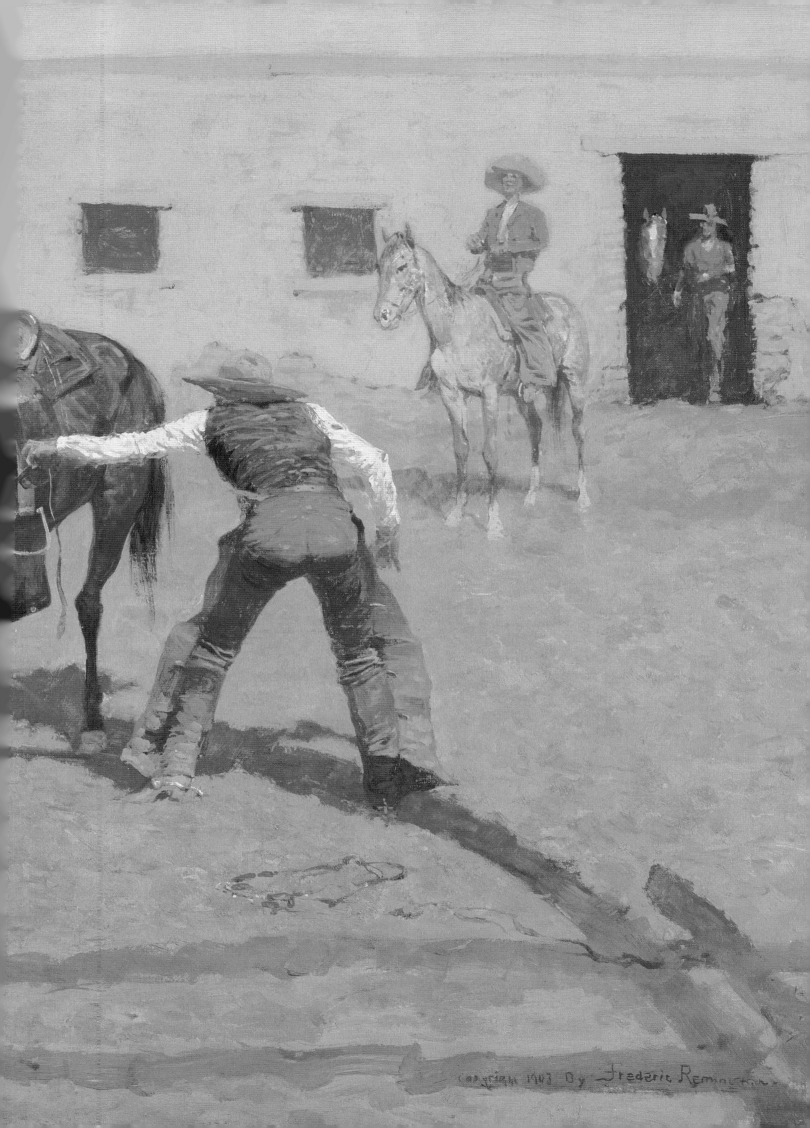

Copyright 1903 by Frederic Remington

CHARLES M. RUSSELL

The career of Charles Marion Russell (1864–1926), or "Charlie" as his many friends called him, overlapped that of Frederic Remington, the other celebrated Western illustrator of the period. Remington was famous by 1890 and dead in 1909. Not until two years later did Russell finally have his first one-man show in New York, the nation's art capital. Prior to that time he was essentially a regional artist.

Both men came from well-to-do families. Indeed, Russell's was the better off, owning the Parker-Russell Mining and Manufacturing Company, at one time the nation's largest producer of industrial fire brick. Despite the advantages of wealth and an impressive family background (his ancestors included judges and Revolutionary War heroes), Russell never got beyond grade school and, if his numerous letters are an accurate indication, was nearly illiterate. His talents lay elsewhere.

WESTERN DREAMS

Russell was born at and spent his formative years in Oak Hill, a small community near St. Louis, Missouri. He rode, sketched, modeled animals from clay, and dreamed of the West. His

A Desperate Stand

CHARLES M. RUSSELL

detail; 1898, oil on canvas. Amon Carter Museum, Fort Worth, Texas.
The use of horses as barricades was a common practice on the treeless plains. The artist's detailed knowledge of western weaponry is reflected in the defenders' selection of rifles, up-to-date Winchesters and obsolete Sharps.

interest in the Great Plains and mountains came naturally. His great-uncles, Charles, William, Robert, and George Bent, had been fur traders, and had in 1828 established "Bent's Fort," an important trading post on the Arkansas River.

In 1880, after a final disastrous semester at a military academy in New Jersey, Russell was given permission to accompany a family friend on an excursion into the West. Their trail led to Montana's great Judith Basin, a then unsettled area swarming with game and still traversed by bands of Blackfoot, Crow, and Sioux. Russell's mentor, Wallis (Pike) Miller, had a sheep ranch in the basin, and Russell tried his hand at herding. Like Remington, he did not like sheep; and they tended to get lost under his care. Fortunately, he fell in with an old-time trapper and market hunter named Jake Hoover and spent the next two years roaming the mountains. The fur trade was pretty much a thing of the past, though; Russell benefited primarily from his training in survival techniques and the opportunity to sketch the life about him.

Following this adventure, Russell spent most of the next eleven years working as a cowboy for various Montana cattle ranchers and drivers. He established himself as a night wrangler, a position unappealing to most punchers as it involved spending the hours of darkness on horseback watching over hundreds of cows or horses. For Russell, though, it was perfect—after a few hours sleep, he had the day free to sketch.

Throughout this period Russell strove to perfect his technique and, in his own way, to establish himself as an artist, at least on a local basis. It

The Horse Wrangler

CHARLES M. RUSSELL

cast c. 1924, bronze.

Amon Carter Museum, Fort Worth, Texas.

Russell spent years as a night wrangler on the western trails. No one was better able to depict the clothing, gear, and even the attitude of the solitary cowboy.

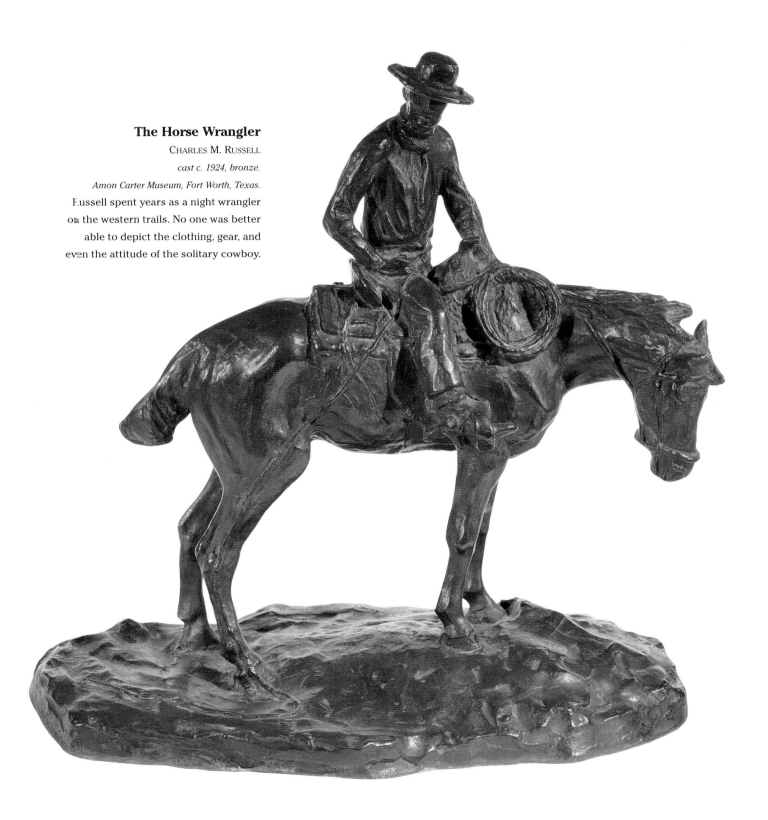

Bringing Home the Meat

CHARLES M. RUSSELL

c. 1891, oil on canvas. Amon Carter Museum, Fort Worth, Texas.

Russell had great sympathy for and had lived briefly with Native Americans. He depicted their daily activities with sensitivity and understanding.

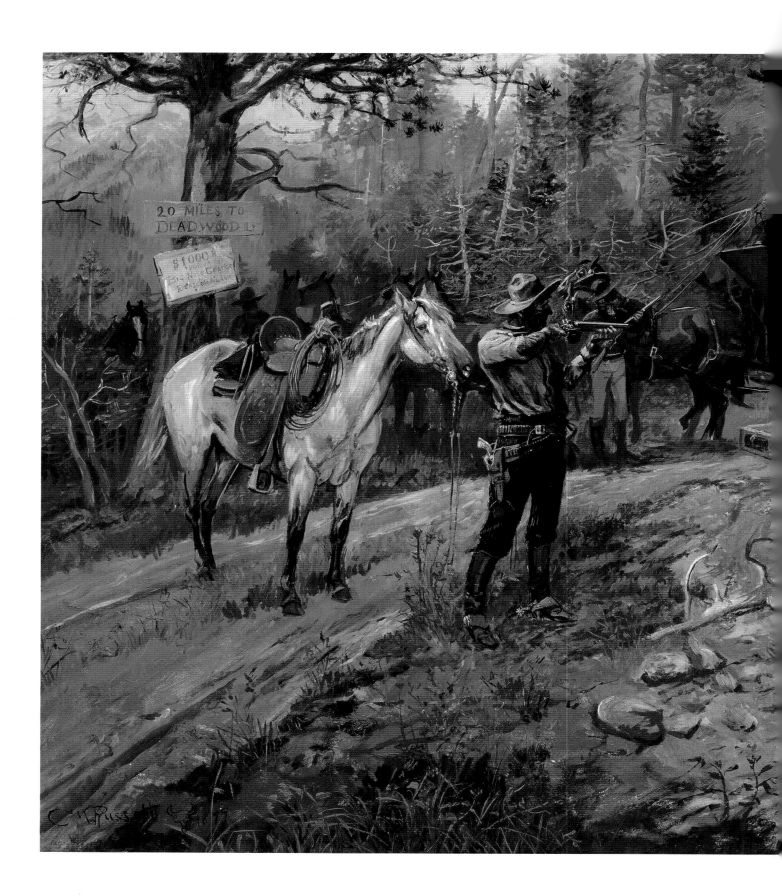

The Hold Up

CHARLES RUSSELL

1899, oil on canvas. Amon Carter
Museum, Fort Worth, Texas.
This painting depicts an
actual event—the holdup
of the Mile City–Bismarck,
North Dakota stage by
Big Nose George, a
notorious gunman who
was soon afterwards
hanged by vigilantes.
The body was flayed by
the undertaker, and his
skin used to make a number
of useful objects, including
a pair of lady's shoes.

111

was typical of his career that his first paid commission was for a mural to be hung in a Utica, Montana, saloon and that as late as 1887 he wrote a friend that "I have tirde [sic.] several times to make a living painting but could not make it stick and had to go back to the range. I expect I will have to ride till the end of my days but I would rather be a poor cow puncher than a poor artist."

A WESTERN WIFE

Charlie certainly realized that recognition could come only through breaking free of his Montana backwater. He could not, however, bring himself to leave the state (indeed, he lived there throughout his life), but he could send his work east. In 1886 he exhibited a large oil, *Breaking Camp*, at the St. Louis Art Exposition and by the following

The Posse

CHARLES M. RUSSELL

1895, watercolor, gouache, and graphite on paper.

Amon Carter Museum, Fort Worth, Texas.

Crime, from murder to horse theft (considered by many the greater offense) was rampant in the Old West. The citizens' answer was the posse, an ad hoc group of paralegal lawmen who, if they caught the perpetrators would as often string them up rather than bring them back to face a jury.

The Scalp Dance

CHARLES M. RUSSELL

cast c. 1904–1905, bronze.

Amon Carter Museum, Fort Worth, Texas.

The gory ritual surrounding the scalp as battle trophy and warrior's decoration often fascinated whites, and variations of this dance appear in many western paintings.

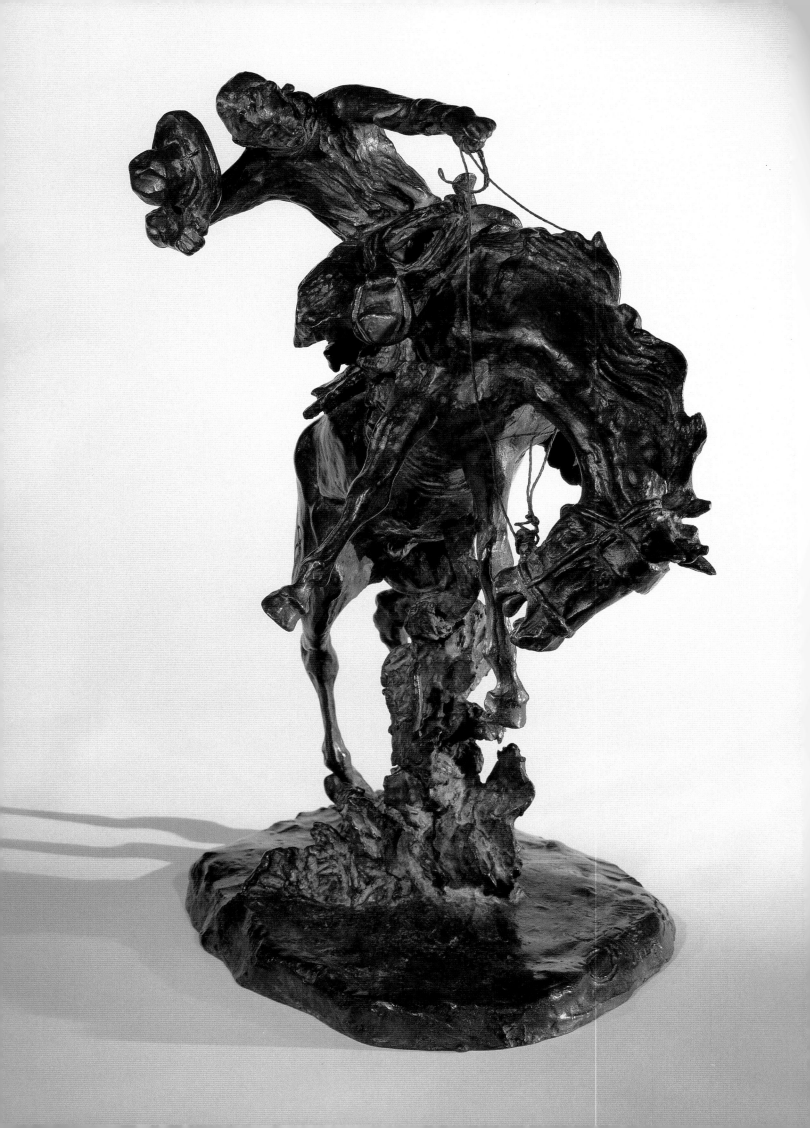

year references to his work had begun to appear in the Montana press.

Nevertheless, it was not until 1893 that he could at last devote himself full time to art. In that year William Niedringhaus, a wealthy St. Louis businessman, commissioned several paintings, and the proceeds allowed Russell to set up a studio in the hamlet of Cascade, Montana. In the next two years, at Cascade and later at Great Falls, the painter turned out some sixty oils and watercolors.

He was still scarcely known outside his home state, but this was to change through the intervention of a woman. In 1895, he met Nancy Cooper, a young woman from Kentucky. Cooper had neither education nor background, but she had ambition and the desire to make the little-known Charlie Russell into a famous illustrator. The couple were married in 1896 and established themselves in Great Falls where, due to a bequest from his mother's estate, Russell was able to build

a home adjoining that of John Trigg, a local tycoon who became a sort of patron to the artist. Nancy then proceeded to remake her husband.

His large circle of friends had always included cowboys, market hunters, trappers, Indians, and various wanderers with whom he would consort at the local watering places, often sketching them and then giving away the works. Nancy quickly recognized that these were unlikely art buyers, and that time spent in saloons was better spent in the studio. The old cronies had to go, and Russell was placed on a rigorous work schedule. His output increased, as did his quality. An illustrated short story published by *Recreation* in 1897 reflected a change in palette. The browns and blacks which had characterized his earlier works were gradually supplemented by lighter and more varied hues, and his composition became tighter and more dramatic.

Left in charge of family finances, Nancy began to demand far more for Russell's work than he had

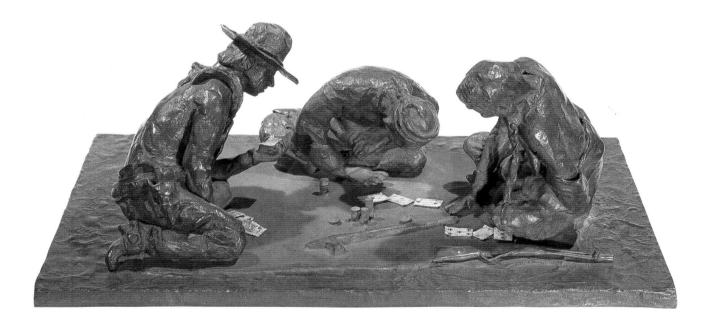

The Poker Game

CHARLES M. RUSSELL

cast 1966, bronze. Amon Carter Museum, Fort Worth, Texas.

Joined in this game of cards are the three great western types—the Native American, the cowboy, and the Chinese.

A Bronc Twister

CHARLES M. RUSSELL

cast c. 1916, bronze. Amon Carter Museum, Fort Worth, Texas.

Long before there were formal rodeos, cow pokes delighted in taming contrary horse flesh and, in the process, showing off their skills to their saddle mates.

ever dreamed of asking. And she got her prices. As sales increased, Mrs. Russell decided to expand their horizons. Late in 1903 she ventured east to tackle the New York market. This decision had been precipitated at least in part by Russell's having been introduced that past summer to the successful Manhattan illustrator John N. Marchand. Marchand had grown up in Indian country and viewed Russell as a fellow Westerner. He promised to show him around the offices of the major New York periodicals.

The Russells spent six weeks in New York. Russell, predictably, didn't like the city, but he made some valuable contacts. Within a few months he was working for *McClure's*, *Leslie's Illustrated Weekly*, and *Outing Magazine* and had been asked to illustrate several books. He had broken into the New York market.

He had also become a sculptor. Unlike Remington, who came to the plastic art in mid-life, Russell had always been interested in modeling, supposedly shaping his first figure at age four. However, his life in the West did not allow for serious pursuit of this field. In New York it was a different matter. A small work in clay, *Smoking Up* (a cowboy on a drunken toot), was, through commission of the city's Co-operative Art Society, cast in bronze. Interestingly enough, one of the recipients of the first copies was Remington's friend Teddy Roosevelt.

Though never as well known as his sketches and paintings, Russell's bronzes proved popular with a group of well-to-do collectors. On a second trip to Manhattan in 1905 he had three more

A Desperate Stand

CHARLES M. RUSSELL

1898, oil on canvas. Amon Carter Museum, Fort Worth, Texas.
When Russell ventured west in 1880 the great plains wars were not yet over, and cowboys on the trail might still encounter "hostiles," as depicted in this dramatic battle scene.

models cast, *Scalp Dance*, *Counting Coup*, and *The Buffalo Hunt*. Thereafter, during the course of his life, forty-nine more were set in metal. Known as the "Original Russell Bronzes," having been cast by his authority, a complete set of these fifty-three may be seen at the Amon Carter Museum of Western Art in Fort Worth, Texas. Unlike Remington, whose bronzes always feature humans with animals present only by association, Russell did many animal studies. Works such as *Mountain Sheep*, *Wolf With Bone*, and *Lone Buffalo* reflect an intimate knowledge and keen observation of Western wildlife.

Like his paintings, these show a complex and sometimes contradictory nature. Unlike nearly all other Western illustrators of the period, Russell lived his life in the West. He was provincial in the best sense, in that he knew his surroundings and their denizens and was satisfied with them. Accuracy in detail was always his concern. He kept a studio full of artifacts, and lived with, understood, and cared for his subjects, whether human or animal.

At a time when the adage, "The only good Indian is a dead Indian," was almost universally believed (and practiced), Russell called for tolerance and understanding. He not only respected Native Americans, he stood up for them. He was particularly concerned for the Cree and Chippewa who, lacking a reservation of their own, wandered without roots through Montana and southern Canada. It is largely due to the intercession of Russell and other like-minded individuals that in 1916 the Rocky Boy Reservation was created for these tribes.

On the other hand, Russell despised the farmer (whom he commonly referred to as a "nester") as well as the tourist. He loathed the former for fencing off and plowing up his beautiful Judith Basin, driving away the game and Indians and destroying the cowboys' livelihood by fencing the open range. His complaints against tourists were many, ranging from their lack of appreciation and understanding of Western life to the way they "defiled beauty spots with their leavings of banana peels and dill-pickle butts and Sunday supplements and empty pop bottles." Ironically, of course, his popular art was one of the reasons tourists flocked to the West.

Russell's first one-man exhibition took place at St. Louis' Noonan-Kocian Galleries in 1903, and

Just a Little Pleasure

CHARLES M. RUSSELL

c. 1898, watercolor, gouache, and graphite on paper.

Amon Carter Museum, Fort Worth, Texas.

As a roving cowboy Russell knew the joys of bar and bordello, but his wife, Nancy, quickly cured him of that, setting his nose to the artistic grindstone and shaping a highly successful career.

his paintings were displayed at the 1904 St. Louis Exposition, Seattle's Alaska-Yukon-Pacific Exposition in 1909, and, from the early 1900s, at two of Montana's most famous saloons, the Mint and the Silver Dollar, both at Great Falls. Then, in 1911, Russell finally reached the New York City market with a major exhibition of oils, watercolors, and bronzes at the prestigious Folsom Gallery. Highly praised by the *New York Times* critic, this show led to an important commission, a painting for the Montana State Capital building, and shows in Calgary, Canada, (1912) and London—The Anglo-

American Exposition of 1914.

Throughout this period the quality of Russell's work continued to improve as did his income. By 1920 Charlie and his wife were financially well established. Though his fame grew, the artist's health declined. He expired following a heart attack on October 24, 1926. Appropriately enough, Russell's most fitting eulogy came from a man named Horace Brewster, not an art world figure or a rich patron but just an old-time cowpuncher: "He never swung a mean loop in his life, never done dirt to man or animal, in all the days he lived."

Mountain Mother

CHARLES M. RUSSELL

cast c. 1924, bronze. Amon Carter Museum, Fort Worth, Texas.

Russell started molding animals of clay as a small boy, and his depictions of wildlife were always accurate and sensitive.

FOLLOWING PAGE:

In Without Knocking

CHARLES M. RUSSELL

1909, oil on canvas. Amon Carter Museum, Fort Worth, Texas.

Perhaps no thirsty cowboy fresh from the cattle trail ever really rode his horse into a saloon, but Russell's popular painting has made us believe it happened.

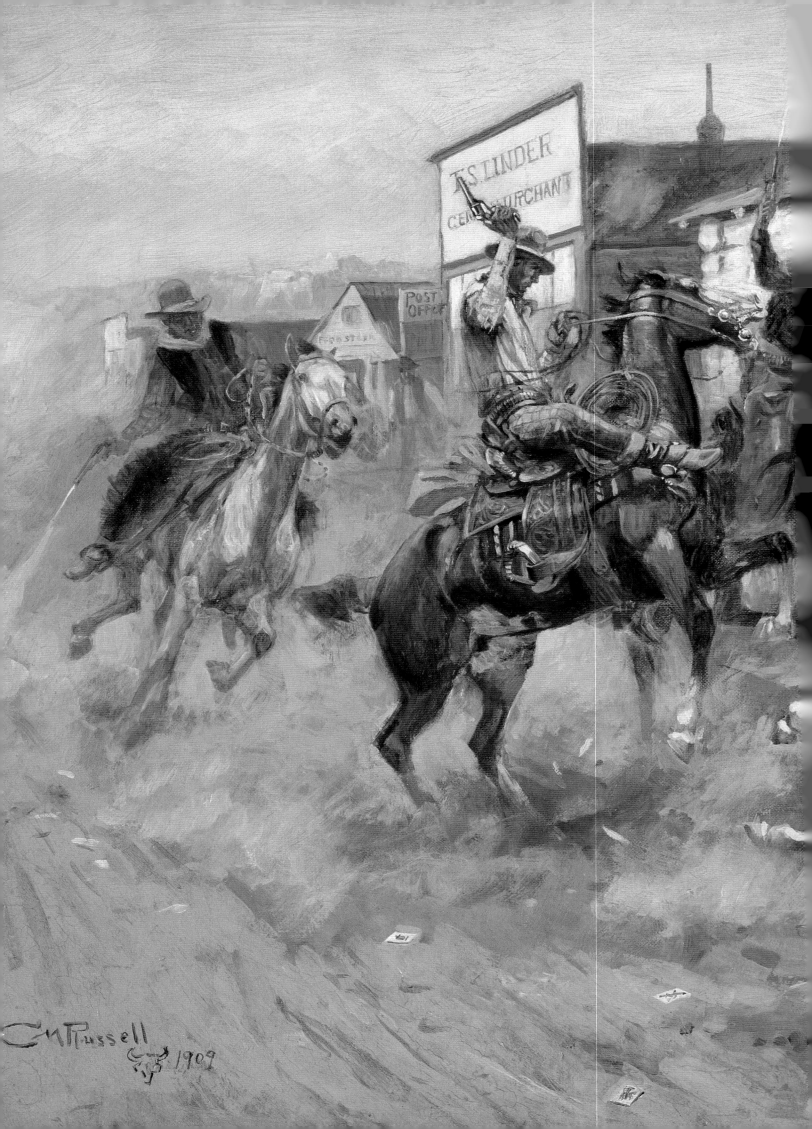

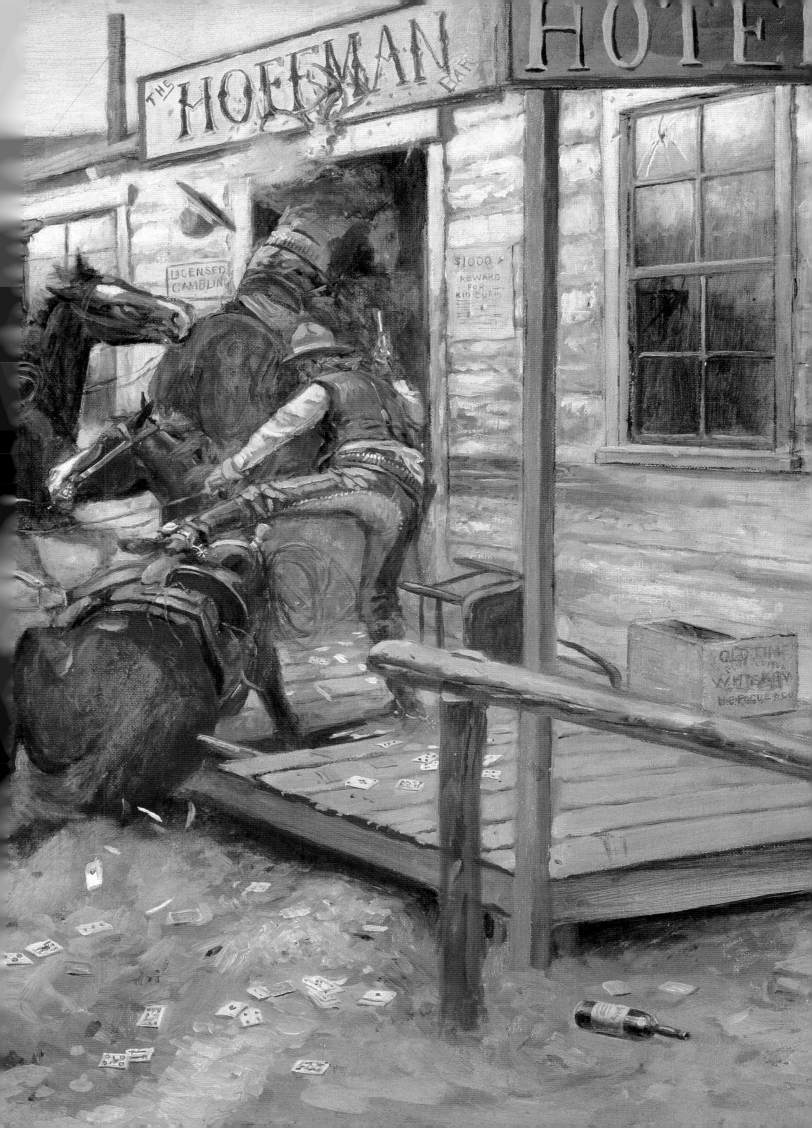

**Buffalo, Crane, Fish,
Blackbird, and Blue Bird**

UNKNOWN LAKOTA SIOUX ARTIST.

Private collection. late 19th century

ledger drawing, ink and watercolor on paper.

Native Americans often depicted the wildlife about
them. Ledger drawings represent a transitional
phase between traditional age-old pictographic
art and the white-influenced but native inspired
works produced by primarily academically trained
Native Americans during the 1920s and 1930s.

NATIVE AMERICAN ART

No book on the art of West could be complete
without recognition of the art and craft of Native
Americans. Yet the very nature of this material
sets it apart from the artistic mainstream. In the
first place the Indian artist in the West was pri-
marily a pictorial historian recording, initially on
buffalo hide and later on muslin or paper, the
important events of his life and that of his com-
munity. Thus, he might create a series of "winter
counts," documenting the significant occurrences
in a tribal year measured from the first snow of
the year to the next or illustrating a particular
event such as a major battle. On a more personal
level a warrior might set down on a buffalo robe,

shield, or tent cover those exploits in raid and combat which served as the highest distinction among the Plains tribes.

These artists did not paint landscapes, still lifes—certainly not in the way we normally visualize such pictures—or anything of what we might regard as "art for art's sake." The Native American was interested in pictorial art only in so far as it served a practical historical or magical purpose, as in certain abstract designs that related to

Big White Man Shooting Buffalo

SQUINT EYE

1887, ledger drawing, ink and watercolor on paper.

Private collection.

Native American Ledger drawings were pictographic portrayals employing watercolor or pens and ink on common merchants' ledgers. Squint Eye, a Cheyenne, is one of the best known Ledger Artists.

Blue Horse

ROAN EAGLE

c. 1890–1895, ledger drawing, ink, crayon

and watercolor on paper. Private collection.

Roan Eagle, an Oglala Sioux, is known for

highly detailed renditions of Indian costume.

dreams depicted on shields and weapons to ward off injury.

Prior to contact with white men in the early nineteenth century Native American artists created pictographs, a form of visual language in which humans were viewed from the front with geometric or "playing card" bodies, while animals, drawn always in a side view, could be identified by prominent characteristics such as horns or tails. Pictographs and their stick-figure characters are as old as man, and examples have been found throughout the world. The earliest existent American example on buffalo hide is a representation of a late eighteenth-century battle between the Sioux and the Mandan which was collected by the Lewis and Clark expedition in 1805 and presented to President Jefferson. It is now at Harvard's Peabody Museum.

Though some Native Americans continued to use hides and natural pigments until the late nineteenth century, a few others were quick to adopt European materials. When, in 1832, the artists George Catlin and Karl Bodmer visited the Mandan artist Mah-to-toh-pa (Four Bears), he quickly accepted and familiarized himself with paper, pencil, and watercolors.

Four Bears (who was dead by 1837 from a smallpox epidemic) was the progenitor of a line of Native American artists who gradually altered the traditional schematic pictographic drawing, infus-

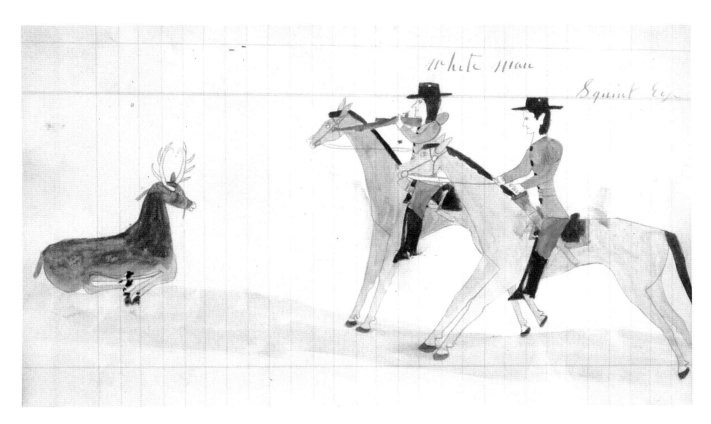

White Man and Squint Eye Killing Deer

SQUINT EYE

1887, ledger drawing, ink and watercolor on paper. Private collection.

Squint Eye took up drawing while imprisoned with other Native Americans
at Fort Marion, Florida. The shift from pictogram to realism in Native
American drawings indicated a rapid and dramatic cultural displacement.

ing it with European elements that added a new kind realism and fluidity to the work. Static symbolic representations of men and animals were gradually replaced by more recognizable forms, culminating in the 1870s in the work of the so-called Ledger Artists.

Native American Ledger drawings—pictographic portrayals employing watercolor or pens and ink on common merchants' ledgers—in fact represent a transitional phase between traditional age-old pictographic art and the white-influenced but native inspired works produced by primarily academically trained Native Americans during the 1920s and 1930s. While in general the pictograph suggested itself, the ledger work made its meanings clear. Abstract representations, both of figures and events (i.e., hour-glass figures to represent slain enemies, horns to represent buffalo), are replaced with detailed images. Clothing, weapons, horse tack, and features are meticulously worked out.

This concern with realism and detail reflected not only the demands of a paying white audience—for which, of course, much of this work was produced—but also, perhaps, a profound change occurring in Native American reality. The abstraction of the pictograph had served well in a society infused with well comprehended mysticism, and a bird's flight or a cloud movement could appear to have great or ominous portent. The crushing presence of a highly pragmatic alien culture forced another kind of reality upon the native artist, and this was what he or she attempted now to communicate.

Painted Buffalo Skin Robe

MANDAN

Probably collected by Lewis & Clark, 1804–1805.

Peabody Museum, Harvard University, Cambridge, Massachusetts.

The painting on this robe represents a battle fought around 1797 between an alliance of the Sioux and Arikara against the forces of the Mandan and Hidatsa tribes.

INDEX